Art Smart

The Intelligent Guide to Investing in the Canadian Art Market

by Alan D. Bryce

THE DUNDURN GROUP
TORONTO

Editor: Jennifer Gallant
Design: Alison Carr
Printer: Webcom

Library and Archives Canada Cataloguing in Publication

Bryce, Alan D.
 Art smart : the intelligent guide to investing in the Canadian art market / Alan D. Bryce.

Includes bibliographical references.
ISBN 978-1-55002-676-4

 1. Art as an investment. 2. Art, Canadian--Collectors and collecting. I. Title.

N8600.B79 2007 332.63 C2007-900909-3

1 2 3 4 5 11 10 09 08 07

Conseil des Arts du Canada Canada Council for the Arts Canada

ONTARIO ARTS COUNCIL
CONSEIL DES ARTS DE L'ONTARIO

We acknowledge the support of the Canada Council for the Arts and the Ontario Arts Council for our publishing program. We also acknowledge the financial support of the Government of Canada through the Book Publishing Industry Development Program and The Association for the Export of Canadian Books, and the Government of Ontario through the Ontario Book Publishers Tax Credit program, and the Ontario Media Development Corporation.

Care has been taken to trace the ownership of copyright material used in this book. The author and the publisher welcome any information enabling them to rectify any references or credits in subsequent editions.

J. Kirk Howard, President

Printed and bound in Canada.
Printed on recycled paper.

www.dundurn.com

Dundurn Press
3 Church Street, Suite 500
Toronto, Ontario, Canada
M5E 1M2

Gazelle Book Services Limited
White Cross Mills
High Town, Lancaster, England
LA1 4XS

Dundurn Press
2250 Military Road
Tonawanda, NY
U.S.A. 14150

Art Smart

This book is dedicated to Virginia "Ginny" Clarke (1921–2001) and Doris McCarthy (born 1910), artists who taught us how to "see."

Contents

Acknowledgements

I want to thank all the artists, past and present, for their dedication to a difficult and often underrated profession. I know most of you do what you do because you have no choice in the matter; you have to do it because you love to create and must follow your passions wherever they lead you. I also recognize that for the large majority of you it is not an easy road to follow — it is indeed the road less travelled.

Through the process of researching and writing this book, I feel I have gained a better understanding of the commitment and hard work required to complete all creative endeavours. "When we are writing, or painting, or composing, we are, during the time of creativity, freed from normal restrictions, and are opened to a wider world, where colors are brighter, sounds clearer, and people more wondrously complex than we normally realize," wrote author Madeleine L'Engle. This book is my way of trying to return to you a small part of the immense joy and pleasure your skill, determination, and magic has brought to my life. It is my hope that maybe, in some meaningful way, I can influence Canadians to get excited about having more original art in their lives and living places and therefore help support your vocation by investing in art.

In particular, I want to thank Beth Bruder and the staff at Dundurn Press for their unqualified support from the start of this project. I also want to thank Stephen Smart, author, lawyer, and art consultant; Kathyrn Minard, fine art consultant and owner of Contemporary Fine Art Services; Rob Cowley, managing director of Joyner Waddington's Canadian Fine Art Division; Dan Zakaib, fine art appraiser; Roxanne Joseph, research assistant; Kostas Xenarios and

Helen Chialtas, conservation directors at XC Art Restorations; Nathan Vanek, author, friend, and art dealer; Emmett and Sally Maddix of Emmett's Custom Framing Ltd.; Gwyneth Dolan, author and editor; Terry Weatherall, private art dealer; Donald Davis, insurance broker; Barbara Mitchell, art appraiser; and everyone else who supplied research, editing, and information that helped in the writing of this book. I also want to thank the staff of Passages Art Inc. and Passages Move Management, especially Steve Torma, for all their encouragement and support during the writing of this book.

Finally, I would like to thank my wife, Karie, and my children, Christian, Benjamin, Roxane, and Sacha, for supporting my obsession to buy art, start up an art business, and finally write a book on the subject.

Disclaimer

This book, *Art Smart*, is not in any way meant to render legal, accounting, or investment advice or to act as a substitute for any other professional services concerning any and all areas of investing in art or the art market. It should be used only as a helpful guide and is, by and large, based on the personal opinions and experiences of the author.

If you require legal, investment, or other expert assistance about the various topics covered in this book, please consult a competent, licensed professional. The purpose of this book is to educate and entertain, and no financial or aesthetic decisions should be made based solely on the information or advice given in this book. All decisions regarding purchasing artworks or art services remain entirely with the reader.

Introduction

I purchased my first original painting from an art gallery in the Yorkville area of Toronto in the summer of 1965. It was a very colourful oil painting of a whirling bullfighter by Canadian artist Nell LaMarsh. (She is still a prolific and passionate artist. I recently met with her in her studio and showed her that same painting from over forty years ago.) There was something very captivating for me in having my own original artwork with actual gobs of paint on its surface that I could not only appreciate with my eyes but also feel with my hands. It was at once sensual, tactile, and thrilling. To this day I am a big fan of impasto, the technique of applying paint very thickly to the canvas. I was soon back to purchase my next painting, and that was the beginning of my lifelong interest in original art and having it as a constant companion in my life.

My wife's favourite aunt, Virginia (Ginny) Clark, was a very strong influence on our appreciation and accumulation of artwork and other collectables for many years. Ginny was one of those eccentrics that you read about in Dickens novels but rarely experience in life. She began collecting for a house that she was planning to own and furnish someday down the road. She collected different styles of furniture, from Edwardian to Victorian to contemporary, and had all the accessories to go with each room, from rugs to lamps to Flow Blue china. As her possessions accumulated, she packed to overflowing every room in her large apartment and also filled multiple storage units in various parts of Ontario. Ginny's dream of owning her own grand home never materialized, but she continued to be a passionate collector, although a lack of space eventually led her to confine her collecting to exquisite jewelry and precious gems. Late

at night, she would bring out her opal collection and marvel for hours on end at the fire and beauty within them and find great satisfaction in her dazzling "children." She had an artist's eye for beauty and detail and, like all true artists, she changed our way of seeing forever.

Ginny was a commercial artist and was close friends with many local artists, including Donald MacKay (Mac) Houstoun, William (Bill) Griffith Roberts, and Tom Hodgson, to name just a few. Her offices and studio were located on Merton Street, in central Toronto, right above the Merton Gallery. In the early seventies the gallery featured a show by an artist named Doris McCarthy, who had taught art for forty years at Central Technical School in Toronto and was now retired and painting full-time. Ginny told us that these paintings were the work of a great artist, destined to be recognized as one of Canada's finest, and that we should think seriously about starting to collect her work. (Doris later told me that Ginny was one of the first to recognize her work for what it was and was an early enthusiastic supporter.)

Our appreciation of Doris's art grew over time. At one of her shows, in 1987, we walked into the Wynick Tuck Gallery on the sixth floor of 80 Spadina Avenue and a large (five-by-seven) oil painting called *Iceberg Fantasy* was hanging on the wall second from the entrance. I was astonished by its beauty and magnificence. Its overwhelming presence produced in me an involuntary vocal response — something like a groan or exhalation from deep within. It was not the first time in my life that a painting had stopped me cold. I first experienced that same sensation when, during a visit to the Art Institute of Chicago, I turned a corner and came face to face with Renoir's *Two Sisters (On the Terrace)*. I was frozen in awe. I had never seen anything as beautiful as that painting in my life. Her skin looked real and her eyes seemed to be gazing at me with a look that was at once mysterious, vulnerable, and enchanting. I fell in love, on the spot, with that painting. I never fail to visit my first love every time I am back in Chicago. Since the Renoir could not be purchased for any amount of money, and McCarthy's *Iceberg Fantasy* was for sale, I knew I was not going to leave the gallery that day without owning it. Its overwhelming power, beauty, and strength connected to something inside me in a primordial sense. The asking price was seventeen thousand dollars, an enormous amount of money for one painting at that time in my life,

and as I had never paid more than two thousand dollars for a painting before then, it constituted a quantum leap. For good measure, we also purchased a full-size watercolour called *Mountain Image*, also by McCarthy, for three thousand, because it too was irresistible. A cool twenty grand plus taxes in one shot for two paintings!

With small children and a big mortgage, it was hardly the most prudent way to spend money I did not have. However, there was absolutely no doubt about the certainty of my decision. I well remember sitting in the small café in the building and experiencing the mixed emotions of knowing that I had to have those paintings along with the dread of wondering how I was going to come up with the money. Thankfully, David Tuck and Lynne Wynick of the Wynick Tuck Gallery gave me very generous, extended financing to pay for my treasures, and eventually they were paid off, although others kept getting added on to what came to be a never-ending line of credit. I also recall the very next day phoning Christopher Hume, art critic for the *Toronto Star* at the time, and asking him if he thought what I had just done was likely to prove a wise investment in the long run. He reassured me with his words, "You will never go wrong with buying Doris McCarthy." It was the beginning of my lifelong romance with the art of Doris McCarthy. Lynne Wynick was recently quoted as saying, "A buyer becomes a collector when they must have a work of art."[1] She was right, and I was hooked.

We became regular buyers at Doris's shows, mostly collecting her Iceberg Images (oils) and Iceberg Dreams (watercolours), along with other landscape paintings. We would arrive early on Wednesday, as the show was being hung in preparation for its opening on the upcoming Saturday. We would carefully reflect on each new painting and, under the guidance of — and sometimes in competition with — Ginny, put blue dots on a dozen or so paintings to have them held for us for a few days. We would then return on the Friday to narrow our selection down to four or so and finally purchase on Saturday the ones that we simply could not live without. We soon realized that when you are faced with works of art that speak to you and that you love, you'd better take them or you may never see them again. As Ginny had taught us, "It's only the things that you don't buy that you will someday regret," and she was right. Or, as Doris McCarthy told us on many occasions, "Take the tarts

when they are passed, my dears." Thankfully, we took their advice and amassed a lot of lovely "tarts."

In October 2000, Aunt Ginny passed on. Her apartment was so completely packed with paintings, antiques, and collectables that some rooms could hardly be pried open. Some rooms were so full that they clearly had not been entered in thirty years. When we were finally able to enter those rooms I was reminded of Howard Carter's response to Lord Carnarvon when he was asked to describe what he saw when he gazed into King Tut's tomb for the first time. In state of awe, he replied, "Wonderful things." Yes, her whole place was filled with wonderful things! Because she died intestate, we had to purchase almost everything she owned, including hundreds of paintings, through Ritchies Auctioneers in Toronto. These auctions, which because of the quantity of her possessions were spread out over almost a year, gave us a tremendous education into the world of auctions. Our new knowledge led us to the practice of previewing and attending almost all of the available auctions for many years to come. We were now definitely addicted to the intriguing and fascinating world of art and auctions.

Soon after, I decided that I wanted to combine my love of collecting art with a business. I partnered up with an experienced art appraiser, Barbara Mitchell, and began Passages Art Inc., a private art business specializing in investment quality Canadian art. It was a great time to start an art business because Canadian art was just beginning to hit its stride and the art market in general was in the midst of a huge world-wide expansion. We built up a large inventory of "name brand" Canadian art, and eventually my relocation company, Passages Relocation Service, bought a fantastic building in the Beach area of Toronto in 2002 and we set up an art gallery on the beautifully renovated main floor. Although we had individual and group shows from time to time, our business was mostly one on one and private in nature. In 2004, my company sold the building, and now I have a private art business with a number of private and commercial clients.

Of course, my consuming passion is still the art of Doris McCarthy. I serve on the board of directors at her gallery at the University of Toronto and continue to collect her work along with that of other fine Canadian artists. At present, our business evidently owns the largest

collection of Doris's work in Canada, along with three hundred or so other paintings, sculptures, and photographs.

When I talk to people about art and the art market, explaining their options and giving them the basic information they need to make good choices, I find that I often go over more or less the same ground, depending on how much experience the person has in the art world. Inevitably, while trying to provide all the necessary information, I leave something out or simply run out of time. I have often wished that there was a book that would act as a primer for the Canadian art market and cover as many bases as possible for both new and experienced art investors. After they had a chance to read through such a book, they could then come back and discuss the art market armed with some basic knowledge and a clearer and more focused idea of how they wanted to proceed. I wrote this book to answer this need, and I trust you will find it helpful. I certainly do not pretend to know everything, but perhaps what I have learned through years of experience in the art market can prove useful to you or at least serve as a starting point for your own personal journey of discovery. In his eighty-seventh year, Michelangelo (1475–1564) was quoted as saying, "*Ancoro imparo*" — "I am still learning." I very much feel that way myself about art, artists, and the art market.

This book, *Art Smart: The Intelligent Guide to Investing in the Canadian Art Market*, is intended for everyone who is interested in knowing more about the world of original art in Canada. That world can often seem inaccessible, mysterious, and designed for only the very wealthy. In fact, all of us regularly purchase art for our homes and offices. My intention is to help you break through some of the "artspeak" and exclusivity inherent in the art world with the purpose of levelling the playing field for the average person and motivating more Canadians to get involved with the art market by investing in original fine art.

Art Smart does not cover the history of Canadian art and artists or art movements in any detail. There are plenty of books in circulation that examine those topics in depth and with great expertise. *Art Smart* is designed to help both neophytes and, hopefully, even experienced collectors add to their confidence and improve their understanding of the various choices, risks, and opportunities that abound within the wide and intriguing world of Canadian fine art.

Art Smart is divided into three sections. **Section One: Inside the Frame** explains how a work of art is judged for quality and value. It demystifies art terminology and clearly defines different materials, mediums, and movements. Framing, conservation, and restoration are all explained, as they all impact what goes on inside the frame. Finally, information and strategies are provided to help you avoid becoming a victim of fakes, frauds, or forgeries.

Section Two: Outside the Frame discusses the entire art market, from private sellers to dealers, auction houses, the Internet, and other alternative sources. It gives art consumers the information they need to buy and sell wisely, along with an extensive understanding of the pros and cons of each of the many choices that are available outside the frame and within the art market.

Section Three: Beyond the Frame deals with the long-term investment aspects of owning art. It enlightens readers about the possibilities and joys of building their own art collection. It includes tax and succession planning, art scams and thefts, insurance, and copyright issues.

I hope you use *Art Smart* as a launching pad to explore more fully the areas of the art market and/or the artists that most appeal to you. I also hope that by doing this you can add joy, meaning, and richness to your life, as the energy and life force that artists put into their work somehow transmute your being and you experience the transformative power of art. We live in a very fast paced world where much of our lives are focused on the future instead of what's happening right now. Art forces us to stop and look intensely at what is directly in front of us, even stare transfixed, as it draws us in and transcends our thinking and rational minds and cuts through to our individual or collective unconscious selves. As Group of Seven painter J.E.H. MacDonald said, "The essential idea of Art [is] a quality of human consciousness, rather than professionalism, or commercialism."[2] Art may not be able to change the world, but it can act as a catalyst in the raising of our individual consciousness, and when that is transformed, then the world is also.

When I asked artist Doris McCarthy why she thought her paintings are so appealing, she said, after a moment's reflection, "It is the love that I put into each painting: the love of nature, the love of painting, and the love of the present moment." Yes, I very much agree with her, and I truly

love being in the presence of art that comes from, as Paul Klee said, "the womb of nature at the source of creation, where the secret key to all lies guarded." I would be very pleased indeed if some of you dear readers would similarly develop, through this book, an enhanced appreciation for artists and for the pleasures and rewards of owning original fine art.

SECTION 1:
INSIDE THE FRAME

CHAPTER 1

How Value Is Determined in a Work of Art

"There exists a remarkable consensus among dealers and the art world in general about which paintings are desirable. ... Quality seems to be simply 'known', though practically impossible — and unnecessary — to quantify."[3]
— Steve Martin, comedian and art collector

At the age of twelve I visited the Metropolitan Museum of Art in New York City, where I saw the magnificent *Aristotle with a Bust of Homer* by Rembrandt, which was at that time the most valuable painting ever purchased. Just to the side of the large picture was an artist copying the painting to scale, and to me it looked identical. I said to the artist, "Since this was purchased recently for $2.3 million and your picture looks exactly the same, what would your painting be worth?" He replied, "Almost nothing." I was shocked and asked him why, and he said, "Because that is the original, where the spark of genius, the gift of God, came from, and mine is just a copy." Originality, the spark of genius, the gift of God: these and many other factors all combine to make a great painting that is highly valued.

Oscar Wilde said, "All beautiful things belong to the same age." While that is very often true, tastes change and evolve over time. What is considered valuable and beautiful in one age may be undervalued by the next generation. Often, inspired artists are ahead of their time, and the general population has to grow to appreciate what they see and what

they are trying to express through their art. Even the Impressionists were lambasted by the critics in their day. Take for example the critical review, in 1873, of an exhibition by Monet, Degas, Pissarro, and Cezanne that called it "debauched, nauseating and revolting."[4] Ann Landi, in an article called "Turning the Tides of Taste," writes, "Not even the best-trained eyes or the most knowledgeable of art historians can say for sure what will survive for the ages."[5]

There is a general consensus about what constitutes great art, with certain criteria forming the basis for judgment. Primarily, a picture must be skillfully executed and the talent of the artist should shine through the canvas. These skills include the mastery of technique, composition, harmony, colour, perspective, and focus. In addition, the painting must exhibit originality and mystery to set it apart from other works of art. Glen Warner, print collector and journalist, says, "A painting is either good or it's not, it's creative or it isn't, it has a creative spark or it doesn't."[6]

A quality painting will grab your attention and force you to look at it so that you return to it again and again until it captures you. Pierre-Auguste Renoir commented on this phenomenon: "The work of art must seize upon you, wrap you up in itself and carry you away. It is the means by which the artist conveys his passion." Or, looking at it from another perspective, it has been said, "Don't try to discover a great work of art. Let a great work of art discover you." Either way, great paintings seem to appeal to many people in a very comparable manner over time. It is that consistent acceptance throughout the generations that makes a work of art a true masterpiece that belongs to the ages.

Although talent and originality are paramount, what ultimately determines the value of a painting is the popularity and reputation of the artist. There is a tremendous prejudice in favour of established artists. Artists' names and reputations are key factors in the value of their art, just as designers' names sell clothes in the world of fashion and stars' names increase the box office appeal of movies. The most highly valued paintings in the world are all works executed by the most well known artists whose reputations and lives are part of the collective experience of our civilization.

To help overcome this prejudice in ourselves, it can be an interesting experiment to stroll through galleries and museums and auction

house previews without looking at the artists' names. This way you let the pictures speak on their own merits before being influenced by the name of the artist who created them. So often, people accept that any painting by a "name" artist is a great painting or are at least influenced to give the work greater regard than it might otherwise deserve. It seems to be part of our human nature to seek exterior references from society that help us add context and meaning to our internal perceptions.

Consider the example of *The Man with the Golden Helmet*, for decades displayed by the Bode Museum in Berlin as a painting by Rembrandt. It continually drew such enormous crowds that it was given its own special viewing area in a separate area of the museum. Its striking image was displayed in many venues around the city and was even featured on numerous commercial advertisements and logos. It was the star painting of the city, without a doubt! When it was discovered in 1985 through modern technological testing that the painting was likely painted not by Rembrandt but by a contemporary in his studio, it very quickly sat lonely and largely ignored on an ordinary wall of the museum. What had changed? The painting remained the same; only the attribution was different. It is unfortunate but also inevitable that people are often so transfixed by the name of the artist that the cult of personality supersedes aesthetic judgment. It is a fact that the artist's name has almost everything to do with the value that is assigned to a painting.

Just to prove how much a name means, even to art experts, in March 2005 reporters from ABC News ran an experiment. They placed four replicas of masterpieces of modern art alongside six other pieces by unknowns. In fact, four of the latter category were done by kindergarten-aged children. The winner, judged to be the best example of modern art from amongst all these paintings, was a framed piece of fabric that was purchased for five dollars from a thrift store. One artist, Victor Acevedo, described one of the children's pieces as "a competent execution of abstract expressionism which was first made famous by de Kooning and Jackson Pollock and others." I wonder if the four-year-old knows what he is talking about? Nevertheless, in the real (or unreal) world of the art market the difference in valuation between a painting by a "named" artist and one by an unknown can be millions of dollars.

You can see for yourself if an artist is listed by checking art encyclopedias and specialized books and databases that compile information about the history of artists and their works. (See Chapter 2: Demystifying Art Terminology and Appendix B for lists of the major artists involved in various Canadian and international art groups and movements.) Artworks that have been accepted by prestigious galleries and cultural institutions, have been included in important collections, or have auction resale histories are valued the most. Membership in exclusive art societies, such as the Royal Canadian Academy of Arts and the Ontario Society of Artists, is an indication of an artist's peer and curatorial acceptance.

All artists have a style and period for which they are mostly known, and these works are attributed the highest value. Atypical pieces, i.e., the ones outside an artist's recognized style or medium, will not be as highly valued, even though they may be just as good or even superior in quality. Any cursory scholarship of the Group of Seven will identify periods, subject matter, and sizes that are preferred. For example, A.Y. Jackson's later artwork is not as highly valued by collectors as are his early works. Lawren Harris's mountain images with snow are among the highest priced paintings in Canada, while his mountain images without snow sell for much less. Are these paintings the best or are they just valued the highest? It is important to understand the distinction if you are going to invest in expensive fine art. Inexperienced buyers are often influenced to buy a painting outside those parameters known to the experts and make their decisions based solely on the reputation and name of the artist. In addition, all artists, even the most acclaimed, have produced a few works during their lifetime of lesser quality. In assigning value to a painting, first comes the name and current standing of the artist, then whether the piece is in the period or style for which the artist is best known, and finally the quality of the painting in itself. As an investor you should be aware that all three of these factors determine the valuation.

The condition of a painting can also affect its value. Collectors prefer paintings that have not been overly restored so they can judge them in their natural condition. The general public prefers paintings that are in good condition, without cracks, water damage, or discoloration caused by environmental conditions such as light, humidity, etc.

Although the frame, which can be expensive to replace, is usually not factored into the value of a painting, you should take it into account if you are considering buying the painting. (See Chapter 3 for more details.) The cost of reframing and conserving a painting can be considerable. A clear signature by the artist, with possibly the date and title, also adds to the value, while the lack of a signature can significantly detract from the value.

In general, oils command higher prices than watercolours, larger paintings (up to a manageable size) sell for more than smaller paintings, and regional paintings are more valued in the area they are from. Long-time art dealer David Nash comments on what sells and what doesn't, based on his experience: "Collectors will spend more for a portrait of an attractive young woman than for a portrait of a man or a woman of a certain age. Horizontal canvases appeal to buyers more than vertical ones. Landscapes with water sell better than those without. Nudity beats modesty. And bright colors trump paler ones." He adds one last observation: "Paintings with cows don't sell."[7]

A painting's valuation is also influenced by its provenance — the historical documentation of the history of its ownership, collections it has belonged to, museum exhibitions it has been part of, and references to it in the literature of the artist. The most complete provenance traces the ownership and location of an artwork from the hands of the artist right up to the current owner. For very old paintings, this can mean a history of five hundred years or more! If the original bill of sale is not available, the provenance can be traced through anecdotal evidence — any references to the painting made either in personal memoirs or in public records.

Illustrious or distinguished past owners, whether individuals or institutions, can significantly increase the valuation of a particular painting. The explanation for this is partly greatness by association and partly the fact that certain people have previously valued the piece highly enough to include it in their prestigious collections. For example, many works of art that have been owned by celebrities, displayed in museums or public galleries, or featured in first-rate galleries command much higher prices than paintings without any of the above accreditations. Without a doubt, notable owners, exhibition history, and gallery association add value. The allure and reputation of a painting is also

enhanced when it is reproduced or mentioned in scholarly works about the artist or the period of art for which the artist is known. These references are all usually cited alongside the painting at auctions to help justify the valuation.

Another important factor affecting the valuation of a painting is the previous sales records for the artist and for similar pieces that are the same size, done in the same mediums, and executed around the same time. There are many databases now available for this kind of research. (See Appendix C for a list of resources.) For Canadian art, Westbridge Fine Art and Heffel's Canadian Art at Auction Index catalogue auction records and have price record indices for not only individual artists but also the groups they belong to, such as the Beaver Hall Group, the Group of Seven, Historical Women Artists, Inuit artists, etc. These values are all taken from auction records, as they are the only consistently recorded pricing available. They will not reflect gallery pricing or sales or any private deals, especially for artists that have not come into the auction circuit. For the most part, auction prices achieved in the past will be used to determine future valuations, but there must be enough sales results on record to establish a consistent pattern for the various mediums, sizes, and dates under consideration.

Finally, valuation is a constantly moving target. In many ways, the art world is run by supply and demand, just like any other market, and there are a finite number of pieces being chased by an equally finite number of collectors. The rarer and more sought after a piece is, the higher its valuation. A cautionary note, however: tastes do change and the art world follows trends and speculative bubbles. A piece that was once highly valued can become out of vogue; the valuation may or may not reflect its current cultural standing. For example, Impressionism looked to be a sure bet in the eighties and nineties but is currently less in favour. Even Andy Warhol's art was out of favour for part of the seventies. For now, the big money and corresponding valuations are being attached to contemporary art. Currently, seven out of the ten most valuable paintings ever sold are by contemporary masters, but many experts feel that market is extremely overinflated and could experience a severe correction in the near future. As one noted collector said, "Our world adds and takes away zeros very quickly."

Vincent Van Gogh lamented, "I can't change the fact that my paintings don't sell. But the time will come when people will recognize that they are worth more than the value of the paints used in the picture." The valuation of a painting is an attempt to recognize in monetary terms all the various factors, both real and imagined, that are inherent in a work of art. Fairly or unfairly, valuation ranks a work of art not only for its artistic merit but also for its popularity and desirability on the open market. Most artists are happy when the valuation of their work increases because in many ways it reflects the approval of society at large for their creations. As art investors, we have to determine for ourselves if the valuation placed on an artwork by others is reasonable, justifiable, and sustainable in the long run.

To further understand how art is valued from both personal and art market points of view, you will have to be familiar the terms that are used to describe art. The next chapter, Demystifying Art Terminology, is a good starting point. Read on.

CHAPTER 2

Demystifying Art Terminology

*"In order for the human community to benefit from
the contributions of the artist, it must first learn the
language that he uses in his work. In order to
understand what is said in a language, you first have
to learn the language."*
— Italian artist Alberto Magnelli (1888–1971)

The art world has its own language that can be peculiar to anyone on the outside and very intimidating to potential purchasers entering an art gallery to look around or browsing through an auction catalogue. You need an extensive knowledge base to understand exactly how to translate all the specialized vocabulary. There are terms for the various art movements and mediums, and the label descriptions carry abbreviations and notations that all have their place in helping one appreciate the context of the artwork. This chapter is designed to give you the basis for understanding "artspeak." Let's begin with the elusive and often controversial definition of the term *art* itself.

What Is the Definition of Art?

Art is broadly defined as the "human effort to imitate, supplement, alter or counteract the work of nature." It also implies the idea of conscious production or arrangement of sounds, colours, forms, movements, or other elements in a manner that affects the aesthetic senses while encour-

aging an intuitive and emotional rather than a rational understanding. Art is created with the intention of evoking such an understanding and response in its audience. It can cause intense aesthetic or primordial feelings and is often the artist's way of communicating these feelings.

Art explores what is commonly called the "human condition," that is, the essence of what it is to be human. Effective art often brings out new insights concerning the human condition, either singularly or en masse, which are not necessarily positive but which often widen the boundaries of the collective human experience. Ann Landi says, "Art provides deep and lasting satisfactions. It can teach us about the past, confirm our humanity, or give us profound aesthetic satisfaction."[8]

The word *art* comes from the Latin *ars*, meaning skill or craft, and by its original and broadest definition is "the product or process of effective application of a body of knowledge." Since the mid-eighteenth century, art has been commonly understood to be a skill used to produce an aesthetic result. *Encyclopaedia Britannica Online* succinctly defines art as "the use of skill and imagination in the creation of aesthetic objects and environments or experiences that can be shared with others."

Psychoanalyst and author Darian Leader says, "Art means to 'make special' certain objects of perception, producing a characteristic tension between the familiar and the admirable and thus creating new aspects of a potentially common world."[9]

Alternatively, there are those who believe that any attempt to limit art to a finite definition is futile. Art historian E.H. Gombrich wrote in *The Story of Art*, "There is no such thing as Art. There are only artists."[10] Contemplate it if you want, debate it if you are so inclined, but my advice is just enjoy it and don't try to define it through rational thought. As Carl Jung wrote, "A good work of art is like a dream; for all its apparent obviousness, it does not explain itself and is never understood."

The term *art* encompasses such diverse mediums as painting, sculpture, printmaking, drawing, decorative arts, photography, and installations. For the purposes of this book it is mainly used to describe paintings and other works of art that have been produced by professional artists for the enjoyment of and acquisition by others.

However you define — or don't define — art, it is important that you approach it with an open mind and not get hung up on any strict

definitions or limitations of language. In her book *Why a Painting Is Like a Pizza*, art historian Nancy Heller writes, "My position is that anything anyone says is art should in fact be regarded as art. Rather than asking, Is X art? I prefer to ask, Is X a kind of art that I find interesting? If not, I won't spend much time looking at or thinking about it. The marvelous thing about art is that it is a vast, amorphous, ever-expanding category, one for which great thinkers have struggled over the ages to provide a precise definition."[11]

Original Works of Art vs. Reproductions

Understanding the extensive terminology used in the art business is vitally important in helping you to understand and determine the value of various works of art. The art business has a unique trade vocabulary with some similar-sounding terms that upon closer examination can mean many things to different people under varying circumstances.

An *original* work of art usually involves the direct hand of the artist on the work. Often, whether it is original or not has to do with the intent of the artist — whether the artist set out to create something original and unique. Some define original art as "innovation as a direct result of a creative idea or concept." An artist can draw from other materials already in existence, but by manipulating those materials in a unique way can produce a result that can be said to be an original. In most cases, for an artwork to be called an original it must not exactly match any other work in existence.

A *reproduction*, on the other hand, is a picture created by any of the myriad reproduction processes, from offset printing to photocopying. Problems arise when terms and phrases are added to describe reproductions in an attempt to make them seem more valuable than they are. Terms such as "limited edition," "hand signed," "numbered," "museum quality," and "estate stamped" are just a few commonly used examples that can confuse an inexperienced buyer. Other terms and expressions that are loosely bandied about include "original print," "copy print," "artist's proof," "giclee," and "original reproduction." See Chapter 4: Fakes, Frauds, and Forgeries for more information on this subject.

The solution lies in understanding the various terms, asking questions, and receiving written assurances about exactly what the terms mean with reference to the particular work you are interested in purchasing.

Mediums: What You Need to Know

The *medium* is the material that was used by the artist to create the artwork. It can add depth to your appreciation of art to understand the terms that describe the various mediums. The most commonly used mediums are explained below.

OILS

Oil paint, which has been used for more than five hundred years, remains one of the most popular mediums. The Flemish painter Jan van Eyck (1395–1441), famous for his *Arnolfini Wedding Portrait*, is often credited as the inventor of oil painting as a day-to-day medium for artists. The popularity of oils grew in sixteenth-century Venice, where the water-durable, slow-drying medium better suited the cool, damp climate than the fresco mediums used elsewhere at the time.[12] Originally oil paint was created from linseed oil, which formed the base to which colour pigments were added. Linseed oil comes from the flax seed, which was a very common fiber crop of that era. Cassandra James, a contemporary American landscape painter, says, "The linseed oil in binders and mediums bounce the light around and give oil paintings a certain glow. You see it in Mona Lisa's face, and much of Tiepolo's and Titian's work."[13]

Oils can be applied very thinly as a glaze or very thickly as impasto or any thickness in between. They dry very slowly, allowing the artists to take as much time as they need to blend the colours together. Oils do not change colour when they dry, so the colour that goes on is the colour that remains. Pigments, which are any number of natural or artificial substances, are ground and mixed into a variety of oils such as linseed oil, poppy seed oil, and safflower oil to produce colour. Different oils produce different sheens and have different drying times. Artists use various tools to apply oil paint, including rags, brushes, and knives, and

sometimes they apply it directly from the tube. Leonardo da Vinci created many of his masterpieces by applying paint directly to the surface of the painting with his fingers!

To paint with oils, the artist must first prepare the surface. The most popular surface for oil painting is canvas, which is made from linen and stretched out over a wooden frame. The canvas is then treated with gessoes, which are made today from titanium dioxide mixed with acrylic binders, rather than the rabbit skin glue and finely ground chalk that was used for centuries.

Oil paints in tubes were made available to artists near the end of the nineteenth century, which freed the artists from having to stop painting in order to grind their own pigments. This allowed for outdoor painting and the ability to mix colours quickly. Impressionism soon followed. "Without colors in tubes, there would be no Cezanne, no Monet, no Pissaro, and no Impressionism," Impressionist painter Pierre-Auguste Renoir proclaimed.

Oil paint can be applied to many surfaces besides canvas. Many smaller paintings created by Canadian artists were done on board, often on both sides to save money. You will see notations on the descriptions of these paintings such as "oil on panel," "oil on board," "oil on paper," and "oil on masonite" that are simply stating the medium and the painting surface. Oil is truly the most versatile and commonly used medium.

ACRYLICS

Acrylic paint is made from three basic ingredients — pigment, water, and a synthetic resin that acts as a binder — along with various other ingredients to improve the paint's performance and fluidity. Acrylics are based on chemical molecules called polymers and are derived from petroleum. Acrylic paints dry very fast, and although they can be diluted with water, they become water resistant once dry. This is the main difference between acrylics and oil paints — their ability to dry quickly. Artist Brad Faegre says, "Time is not the enemy with acrylics. Think of the fast-drying characteristics of the medium as an invitation to paint and repaint, until you see something you like."[14]

Although the permanency of acrylics is sometimes debated by conservators, they appear to be more stable than oil paints. Whereas

oil paints have a tendency to turn yellow as they age, acrylic paints, at least in the fifty years since their invention, have not shown any signs of deterioration.

WATERCOLOURS

Watercolour is a paint consisting of pigment, a binder of gum arabic, a number of other materials, and water. It is usually applied over white paper and it dries quickly by evaporation. Painting with watercolour is sometimes compared to tight-rope walking without a net, because once an artist commits the brush to the paper there is no turning back. Artist Frederick Whitaker (1891–1980) said, "Looseness, or a suggestion of fluidity, is the principal charm of watercolor painting, and the quality that distinguishes it from other mediums."[15]

Watercolour paintings are generally less expensive than similar-sized oils, which for some collectors can be an opportunity to own a wonderful painting by a great artist whose oil paintings are out of their price range. Watercolour is a fabulous and generally underrated medium that often reveals the true genius of the artist.

GOUACHES

Gouache, pronounced /qwash/, is a heavy, opaque watercolour paint, sometimes called body colour, that produces a less wet-appearing and more strongly coloured picture than ordinary watercolour. For the most part, *gouache* can be used almost interchangeably with *watercolour* to describe a medium.

TEMPERAS

Traditionally, tempera was any paint consisting of a pigment combined with a binder. The term was originally used to distinguish it from *fresco*, which is only pigment and water. The term and the process were in use before the invention of oil paints. When the binder is specified, it is included in the name of the medium. For example, tempera made with egg is called "egg tempera." Some artists

have commented that egg tempera combines the advantages of oil and acrylic: it dries quickly like acrylic, can be reworked like oil, allows for a wide range of colour and effects, and does not yellow or darken with age, as oils are prone to do. Diverse painters such as Leonardo da Vinci and Michelangelo used the medium of tempera, as do many modern-day artists.

PASTELS

Pastels are pigments mixed with gum, water, and chalk and pressed into a dried stick form for use as crayons. Works of art done with such pigments are also called pastels. Pastels can fade and rub off, so they are usually framed under glass to protect them from the elements. Artist and lecturer Amanda McLean says, "Pastel is possibly the purest form of painting — we work with pure pigment and little else!"[16]

COLLAGES

Collages are artistic compositions made by gluing various materials to a background. The word comes from the French *coller*, meaning "to glue." Collages can be gorgeous works of art rich in texture and variety. Canadian artist Donald Mackay Houstoun, who made stunning collages for the Roberts Gallery in Toronto during the sixties, stopped producing them because he could never charge enough to warrant all the time and effort it took to complete them. Nevertheless, collages are amongst the most visually stunning artworks, rich, textured, tactile, and sensuous. Artist Robert Motherwell called collage "the twentieth century's greatest innovation."

INKS

Inks are made from black carbon and were used in China and Egypt more than two thousand years ago. Today they may include other colouring materials and chemicals. Some inks are very fluid and others are relatively thick and pasty, each used for different artistic results.

Mixed Media

Mixed media simply involves the use of two or more mediums in one work. It is a very broad term applied to any artwork that is not produced from a single medium.

Sculpture

Sculpture is defined as any hard material formed into a three-dimensional work of art. These works can be representational or abstract, functional or not. Some of the more common materials are stone, marble, granite, metal, paper, plaster, polyester resin, and wood. Sculpture is currently very low on the radar screen of Canadian art consumers, with the exception of Inuit carvings and soapstones, and therefore is an area to watch for future appreciation and acceptance.

Prints

A *print* is defined as a copy of an image produced by, or under the direction of, the artist who designed it. An *original print* involves the active participation of the artist in producing each image.[17] They are original works of art created from a range of techniques or mediums, such as etching, lithography, and serigraphy. All prints are made by pressing an inked or coloured template — a printing surface made of metal, wood, stone, or other material — against sheets of paper to produce a separate and distinct image.

There is a widely held misconception that original prints are second-class citizens in the world of original art. It is not unusual to hear them referred to as "only prints," even by dealers, as though they are inferior to other art mediums. Printmakers are often not held in the same esteem as painters and sculptors. Prints are important to artists — and not just those who are exclusively printmakers. Most of the great masters excelled in printmaking and embellished on the techniques used in the various mediums. A few international notables who used printmaking include Rembrandt, Goya, Miró, and Picasso. More than anyone else, however, it was Albrecht Dürer who established the print as

a major art form.[18] A print allows the artist to make a number of similar images from a single source, thereby increasing the number of available images at a lower cost. The benefits to the artist and the purchaser are obvious.

There are four basic types of prints, each one requiring a different methodology. I have tried to make the definitions as simple as possible to help the reader understand and remember what each term really means.

LITHOGRAPHS

Lithography involves applying a special liquid grease to the surface of different types of porous stone. The artist draws directly on specially treated stones with an oily crayon, and ink is transferred to paper via a high-powered litho press. Up to twenty stones can be used to produce a colorful lithograph: each stone creates a portion of the finished product, and it is only the combination of all of them that results in the image the artist had in mind.[19]

Lithography was invented in 1798 and is responsible for the art of La Belle Époque and such artists as Alphonse Mucha and Henri de Toulouse-Lautrec. Toulouse-Lautrec's posters, produced in editions of up to two thousand in France in the 1890s, are some of the most spectacular and beautiful advertisements ever made. I have seen many of the original posters and they have a vibrancy, strength, and grace that make them deserving of the label "classics." I particularly love the images of Aristide Bruant by Toulouse-Lautrec. I passed one up years ago for $55,000 at Odon Wagner's gallery in Toronto. Since then, I have seen them offered at auction in the range of $150,000.

SERIGRAPHS AND SILKSCREENS

Serigraphy is a twentieth-century technique in which the artist presses ink through open areas of a silk mesh screen onto paper. Fifty or more screens can be used to produce a single image. Serigraphy became popular in the sixties because of its ability to produce bright areas of colour.[20] Silk used to be the fabric of choice, but now cheaper fabrics,

including synthetics, are used. The term *serigraph* more commonly refers to fine art prints, whereas silkscreening is also used for industrial applications. It is derived from the Latin *sericum*, which means "silk," and *graphein*, which means "to write" or "to draw." The terms *serigraphy* and *silkscreening* are often used interchangeably.

Etchings and Engravings, Drypoints, and Mezzotints

These are all examples of intaglio prints, from the Italian *in* ("in") and *tagliare* ("to cut"). They are made by forming grooves in a surface such as wood or metal, forcing ink into the grooves, wiping the rest clean, and pressing paper against the surface so that the paper picks up ink from the grooves. There are many different methods used by artists to produce these prints.

Etchings & Engravings
A metal plate, usually copper or zinc, is coated with a thin waxy substance called the *ground* that is impervious to acid. The artist draws through the ground with an etching needle to expose the metal underneath. The plate is then dipped in acid, which eats through the plate where it has been exposed by the scratching. The plate is then inked and wiped, the ink filling the drawn lines, and the image is pressed onto paper. Numerous plates, treated in various ways, are used to produce coloured etchings. Variations on the technique produce textures, aquatints, and the like.[21]

Drypoints
Drypoints are created by incisive drawing directly into a plate with a steel needle that produces a soft ridge along the incisions called a *burr*. These are produced in very limited editions because of the fragile nature of the burr. They have a soft, velvety effect that is very distinct from the hard-edged line found in engravings or etchings. David Milne is the artist that comes to mind when I think of enchanting drypoint prints.

Mezzotints
These are created by a specific etching process of scraping and burnishing the plate, thereby producing special effects in texture and shading.

This method produces deep black or shades of grey in the print. It has been long associated with illustrations in books.

Linocuts, Woodcuts, and Photoengraving

These are all types of relief prints, which are made by carving away unneeded areas from the surface of a material such as wood, linoleum, or metal, inking the remaining areas, and pressing paper against the inked surface. Specifically, a linocut is created by carving or gouging an image into a linoleum block, then inking the block and pulling the impression.

A woodcut is the same as a linocut except that a wood block or series of blocks is used to create the original print. This method is also referred to as wood block or wood engraving.

Photoengraving is accomplished by coating a sheet of metal with a light sensitive material. Then a film negative is placed over the coated sheet and exposed to UV light. The plate is then treated with chemicals to produce an image in relief.

Marketing Terms

Now that we have the basic understanding of the vocabulary of print-making, let's discuss some of the terms employed in the marketing of prints.

Limited Editions

Artists began to number their prints toward the end of the nineteenth century, shortly after the practice of issuing original prints in small editions became popular.[22] An edition is simply a number of prints created from the same original print or technique. "Signed and numbered" generally indicates that the piece has been numbered to reflect the size of the edition and the particular print's place in the series (e.g., "32/75" means the piece was the thirty-second print of seventy-five that were made from the original) and then hand-signed by the artist, attesting to its authenticity and quality.

ARTIST'S PROOFS

An artist's proof (AP) was originally intended as an example of a "work in progress," but that definition is somewhat archaic, as an "AP" can now represent a mini-edition, usually an additional 10 percent of a larger print edition, usually identified as AP, EA, or PA.

TEXTURED REPRODUCTIONS AND GICLEES

These are mechanically produced reproductions of works of art. Any type of art from any time period can be reproduced, including bronzes, paintings, prints, metalwork, ceramics, and porcelains. Contemporary reproductions of famous works of art are sometimes marketed using a host of inaccurate and possibly misleading terms, including "limited," "authorized," "collector's edition," "precision-crafted using the finest materials and techniques," "unique," "special," and so on. In Canada, these terms are most often used in marketing works by the Group of Seven but may also be used in selling the works of many other famous Canadian artists such as Alex Colville, Christopher Pratt, and Cornelius Krieghoff, to name only a few.

Giclees are reproductions created using the ink-jet process, usually with many colours and high resolution. The word *giclee* comes from the French term for "fine spray." Precise computer calculations control these ink jets to produce more than five hundred shades of dense, water-based ink. A computer directly scans an artist's original work to control the jets. The final product is a quality textured print that has the feel of a watercolour and the look of an original lithograph. Giclees can be also printed on any number of mediums, including canvas, watercolor paper, vinyl, and transparent acetates, reproducing an original artwork almost to perfection.

These reproductions are fine, if the price is in line with what they are — printed copies — but be extremely cautious if they are marketed as investment quality prints or original artworks.

Artist's original prints can be captivating and great works of art in themselves. However, with reproduction prints, the spontaneity and sensitivity of an artist's original works are usually lost in the translation.

On the other hand, quality reproductions allow you the joy of having famous and revered works of art in your home whose originals are forever ensconced in museums and public galleries. Where would we all be without a reproduction of Van Gogh's *Starry Night* at some point in our lives? But when you see the original...

As an example of the available quantities of even some original prints, never mind reproductions, Picasso affixed his signature to approximately 15,000 prints over a period of twenty years. In 1999 an original print of his sold at Christie's for a record US$376,000.

The Initials beside the Artist's Name

Many labels at galleries or listings in auction catalogues contain initials and phrases that are important to decipher. The ones immediately following the artist's name have to do with his acceptance by and membership in prestigious artists' societies or organizations. They are only open to artists who have been judged by their peers to be competent enough to join their group, so it can be an indication of the quality of work of the artist. A second set of abbreviations is used to state the medium used to create the piece.

The designated initials for some of the more important Canadian art societies are:

RCA: Royal Canadian Academy of Arts
OSA: Ontario Society of Artists
SCA: Society of Artists

Some of the more common art abbreviations are:

a/p: artist's proof	gch.: gouache
acr.: acrylic	litho.: lithograph
d.: dated	ltd.ed.: limited edition
ed.: edition	m.m.: mixed media
engr.: engraving	o/bd.: on board
exh.: exhibited	o/mas.: on masonite

o/p.: on panel	silksc.: silkscreen
o: oil	sk.: sketch
pas.: pastel	uns.: unsigned
s.: signed	w/c: watercolour

Artists of Note

There are many buzzwords for groups of artists and periods of art both in the history of Canadian art and in the international art world. Here is a concise overview of the most often used terms and what they represent along with a few of their most well known examples. Please see Appendix B for more complete lists of the artists involved in the various groups and movements, as well as a number of listed Canadian painters and sculptors.

CANADIAN ART GROUPS

The Group of Seven

The Group of Seven is the most significant and dominant group of painters that Canada has ever produced. Anyone interested in investing in Canadian art has to know about them and understand their tremendous influence on the art market. Before them, most Canadian painters studied abroad and painted in the European styles of art referred to as the Barbizon and Dutch schools. "To a Canadian," wrote journalist Augustus Bridle, "scenes in this country are of vastly more interest than all the fishing smacks and brass kettles and sea-weed sonatas of north Europe."[23]

This group of Canadian artists for the first time celebrated the vast and beautiful world of Canadian nature and brought the wilderness into the living rooms of Canadians in a unique and groundbreaking manner. Member Frank Carmichael said, "We shall yet develop a movement that will be distinctive as our native landscape."

The Group (as it is called) was formed in 1920, exhibited for a relatively short time, and was disbanded by 1931. Its members are among the most prominent names in the history of Canadian art. They included Franklin Carmichael, A.J. Casson, LeMoine FitzGerald, Lawren

Harris, Edwin Holgate, A.Y. Jackson, Frank (Franz) Johnston, Arthur Lismer, J.E.H. MacDonald, and F.H. Varley. Some members were added over time and some left, making the total number of members ten — plus Tom Thomson. Thomson is considered the spiritual and artistic inspiration for the group, although he died before they were officially formed and ever exhibited.

Historical Canadian Painters
These painters preceded the Group and painted in the more European style but are an important part of the art market and Canada's artist heritage. Some of these artists include Frederic Marlett Bell-Smith, Lucius O'Brien, Frederick Arthur Verner, William Brymner, Cornelius Krieghoff, Paul Peel, Marc-Aurèle de Foy Suzor-Côté, and Paul Kane.

The Canadian Group of Painters
This group of twentieth-century Canadian artists formed in Toronto in 1933 as a successor to the Group of Seven. Its members included such artists as Bertram Brooker, Emily Carr, Paraskeva Clark, Charles Comfort, and Marc-Aurèle Fortin.

Contemporary Arts Society (CAS)
This group was created by John Lyman and was based in Montreal. Its purpose was to promote living modern artists. It was formed in 1939 and dissolved in 1948. Some of its prominent members included Marian Dale Scott, John Lyman, Eric Goldberg, Stanley Cosgrove, Paul-Émile Borduas, and Alfred Pellan.

Painters Eleven
This group of Toronto abstract painters was active from 1953 to 1960. The Painters Eleven were united in their desire to promote abstract art at a time when doing so was not popular. The members are Jack Bush, Oscar Cahen, Hortense Gordon, Tom Hodgson, Alexandra Luke, Jock MacDonald, Ray Mead, Kazuo Nakamura, William Ronald, Harold Town, and Walter Yarwood.

The Beaver Hall Group

This group consisted of nineteen Montreal artists whose studios were at 305 Beaver Hall Hill. It started in 1920 with Montreal-born A.Y. Jackson as president and its official existence was very brief. After the group disbanded for financial reasons some of the women artists still used the studios. They were joined by other women artists, and this group of painters later became known as the Beaver Hall Hill Group. The members included such artists as Nora Collyer, Emily Coonan, Prudence Heward, Mabel Lockerby, Mabel May, and Kathleen Morris.

Automatistes

This was the most important group of painters in Quebec in the late 1940s through the mid-1950s. They include Paul-Émile Borduas, Marcel Barbeau, and Jean-Paul Riopelle. These artists were bound by their passionate belief in modernism and especially in intellectual freedom. In 1948 they published the manifesto *Le Refus Global*, in which they expressed their deeply held beliefs. The Post-Automatistes period began around 1955 and included artists such as Jean McEwen, Rita Letendre, Lise Gervais, and Jean-Paul Lemieux.

INTERNATIONAL ART MOVEMENTS

Old Masters

"Old Master" is a term for a European painter of skill who worked before about 1800 or for a painting by one of these artists. An Old Master print is an original print (for example an engraving or etching) made by an artist in the same period. Auction houses still usually divide their sales between Old Master paintings, nineteenth-century paintings, Impressionist paintings, and modern (or contemporary) art. Christie's auction house defines an Old Master as a painting created "from the 14th to the early 19th century." Such famous names as Leonardo da Vinci, Albrecht Dürer, Michelangelo, Raphael, El Greco, Nicolas Poussin, and Rembrandt are included in this group, along with a host of lesser known art luminaries.

Impressionism

Impressionism was a nineteenth-century art movement that began as a loose association of Paris-based artists who began exhibiting their art publicly in the 1860s. The name of the movement is derived from the title of a Claude Monet's (1840–1926) work *Impression: Sunrise (Impression, Soleil Levant)*, painted in the late 1860s, and was first used by critics viewing a new exhibition held in 1874. Some of the most famous impressionist artists include Pierre-Auguste Renoir, Claude Monet, Edgar Degas, Mary Cassatt, and Auguste Rodin.

Post-Impressionism

This is a catch-all term for a number of artists who followed the Impressionism movement from around the 1880s until the end of the century. The major names associated with this movement are Paul Cézanne, Paul Gauguin, Vincent Van Gogh, Georges Seurat, and Henri de Toulouse-Lautrec.

Expressionism

Expressionism was the first big art movement of the twentieth century. The term can be used very broadly to describe any art that is emotional and intense, but the term was coined in 1911 to describe an exhibition of the Fauves, early cubists, and other modernists. Famous painters of this movement include Edvard Munch, Henri Matisse, Wassily Kandinsky, and Amedeo Modigliani.

Cubism

Cubism was the first totally abstract art movement. It broke all the rules of art that had been established since the Renaissance. It shook up the art world like nothing that had happened before. The movement was named by a French art critic who called the paintings "wacky cuby things." The innovators in this group are Pablo Picasso, Georges Braque, Juan Gris, Fernand Léger, and Constantin Brancusi.

Dadaism and Surrealism

Dada means "hobby horse" in French, but it is a made-up word designed to poke fun at all the fancy art names that had sprung up over

the years. It was not so much a style as an antisocial attitude. The most important names of the movement are Max Ernst, Man Ray, Marcel Duchamp, and Joan Miró. The concept of surrealism began with the writer André Breton, whose idea was to unite the conscious and unconscious worlds into a higher reality that he called *surreality*. The most famous of these artists are Salvador Dali, Marc Chagall, René Magritte, Alberto Giacometti, and Meret Oppenheim.

Abstract Expressionism

Sometimes called action paintings or *tachisme*, a French term meaning basically "big blobs of colour," abstract expressionism involved dripping and flinging paint onto the canvas without much rational thought and without using any classical training techniques. The big guns are Jackson Pollock, Willem de Kooning, Mark Rothko, Robert Motherwell, and Barnett Newman.

Pop, Minimalism, and Conceptualism

Pop art began after the war in the fifties as the age of consumerism was upon us, and as a response these artists used everyday objects as their subject matter. The king of the pop art movement is Andy Warhol, followed by Roy Lichenstein, Jasper Johns, and Robert Rauschenberg. Minimalism reduced art to simple shapes, and conceptualism took art into the abstract realm of ideas. The drivers in this world are Frank Stella, Carl Andre, and Eva Hesse.

Contemporary

The term *contemporary art* refers both to the visual arts being practised in the present day and, more broadly, art made from the late sixties into the twenty-first century.

In truth, any art being produced today is by very definition "contemporary," but what the term most commonly refers to is categories of modern art such as photography, painting, installation art, video art, Internet art, and new media. For general use, the term *contemporary art* can be defined as new art produced by living artists.

CHAPTER 3

Framing, Conservation, Restoration, and Decoration

"An American lady once protested that the Renaissance painting
of a girl he [Duveen]was trying to sell her had obviously been
restored. 'My dear Madam,' he said, 'If you were as old as this
young girl, you would have to be restored, too.'"[24]
— S.N. Behrman, biographer of legendary art dealer
Joseph Duveen

Before you purchase any artwork and long after you own it, you will
have to consider how it is framed, if it needs restoration, how it should
be protected from damage, and how and where you are going to display
it. As architect and interior designer Geoffrey Bradfield said, "I've always
regarded art as a paramount decorating tool."[25]

Framing

The frame around a piece of art can add tremendously to its value, both
by enhancing its beauty and by preserving its condition, which could
considerably increase its lifespan. Framing can add significant costs
above and beyond the purchase price of a painting and should be con-
sidered as part of the overall expenditure. A good frame can be worth
more than the artwork it encloses, and sometimes it can cost more to
have a picture properly framed than to purchase it in the first place. As
English writer G.K. Chesterton once said, "Art consists of limitation.
The most beautiful part of every picture is the frame."

Your first consideration with any piece of artwork should be whether the current framing and backing do the picture justice, from both an aesthetic and a preservation perspective. Depending on the condition of the artwork and where you purchased it, you can set expectations based on the combination of these factors. In general, most art galleries expect their artists to provide the frames for their work, so the quality of the frames will often be proportional to the success of the artist and the prestige of the gallery. Considering the high cost of framing, only with the most conscientious and prestigious of artists is the quality and longevity of the framing a primary concern.

So, with almost all pictures purchased in the primary market, the purchaser must factor the probable cost of replacement framing now or in the future into the price of the artwork. In the aftermarket, most pictures are sold "as is," and there is a very high likelihood that the framing and conservation will need to be redone, unless the dealer has already taken the care and effort to upgrade the frame and backing materials in line with current conservation technologies and methodologies.

Framing is an art in itself that can make or break a painting from both appearance and conservation perspectives. There are some who believe that the frame should be almost invisible and that its only function is to isolate the artwork from the wall around it, but most understand the added value that a proper frame provides. A good framer is a master craftsperson who can combine just the right materials, layering, colours, spacing, and design to complement the picture and bring it alive, while at the same time protecting it from harm for generations to come.

With more valuable, investment quality, or historical pieces you will need an appropriate frame and backing and the advice and skill of a master framer. Finding the right framer is a research project that requires almost the same amount of time and effort that you put into selecting the painting in the first place. Generally, the most skilled framers have been around for a long time and are well known in the artistic community. Cultural institutions, art consultants, and major collectors may steer you in the right direction, but you have to visit the framer yourself and find one with whom you feel comfortable. Some points you may want to consider are the length of time he has been in business, the variety of choices he offers, and his reputation in the artistic community. You

might also want to ask about the security the shop has in place to guard against theft and fire. A good framer is like a good tailor or dressmaker: once you find one and establish a trusting relationship with him, you will want to keep him for as long as you possibly can.

With treasured paintings, you need a framer who understands the art as well as the practice. The proper frame must suit the time period and genre of the artwork to go well with it and highlight its outstanding qualities. You must choose the type of frame and methodology of framing that best complement the piece. On a valuable historical painting, an original period frame or a well-suited frame using new materials may be the best depending on the picture. The framer may also use an inner moulding and custom colour it to complement the frame. The dimensions and colour of a liner, and whether to use a liner at all, are crucial decisions. There are liners and frames that are cut and joined independently of the picture and then covered or gilded so that the seams are invisible. Often very good frames match perfectly on each corner and even appear seamless.

Sometimes a gold frame is best. A gilded gold frame is more expensive because it actually contains pieces of gold leaf applied to the frame by a skilled artisan, while a gold-coloured frame is just that. Solid wood frames are more expensive than particle board or plaster frames. You have to balance the cost of the frame with the value of the painting and make your decisions accordingly. While the cost and quality of the materials are important, the most important aspect of framing is the experience, skill, and knowledge of the framer. Framing is a very labour intensive craft and good framing takes time and expertise. You do not want your framing done on a production line; the craftsmanship of the framer should mirror either the monetary value of the work or how much it means to you.

Some framers recommend a solid archival backing board on the reverse of the painting, screwed into the frame, to protect the work from behind.[26] Others want to make sure there is room for the canvas to breathe by adding holes for air. Many modern pieces are well suited to a floating frame, which leaves a space between the canvas and the outside wall of the frame. A number of contemporary oil paintings are painted right around the sides of the canvas and therefore do not need any additional framing at all.

Works on paper, including pastels, watercolours, and drawings, as well as etchings, lithographs, and other print mediums, have three natural enemies: acid, light, and moisture. Care must be taken to guard vulnerable artworks from these predators.[27] They need special handling and materials to preserve their delicate nature. Many older works on paper, if they have not already been reframed, will have paper and backings that are highly acidic. Turn over any work and examine it to see if it has a 100 percent rag mat board and backing. If you see cardboard or any yellowing or aging of the matting, especially on the matting bevel core, you can be fairly sure that the piece will have to be reframed. The art must be printed or created on acid-free paper or, more correctly, on 100 percent rag mat board, and the mat and backing must be archival quality as well. As one fine art framer warned, "Masking tape and glue, staples of economy frame shops, are deadly to fine art on paper."[28]

For paintings on canvas or with linen support, according to many framers, some form of archival non-acidic board backing is the single most important preservation step you can take. The protective backing should cover the entire back of the picture and should be screwed into the stretcher or strainer and not into the frame. A proper protective backing will slow the effects of environmental damage and protect the painting from accidental punctures and tears.[29]

Since the seventies there have been incremental improvements and technological advances in the options available to the framing industry. Your framer can offer you many choices and then instruct you on the advantages and disadvantages of each. This is especially true with regards to the choices in glass and glazings that are available. For most works on paper, glass serves to cover and protect the art. A professional framer will give you a choice of glass offering different levels of quality and protection. The three factors to consider are coloration, ultraviolet (UV) protection, and glare. Coloration refers to the greenish tint often visible in glass, which can distort and darken the colours of the painting. The intensity of the tint is determined by the amount of lead in the glass. More expensive glass, sometimes called water white glass, is lead-free and produces very pure coverage with almost no coloration. The UV protection in the glass can be anywhere from nothing to almost 100 percent screening. Your decision on how much protection you need

should be based in part on how much UV light exposure you anticipate the picture will receive. Finally, you need to decide how much, if any, anti-glare coating you want on the glass. Glass with no coating will reflect light, causing glare that can detract from your enjoyment of the artwork, while full anti-glare coating can produce completely non-reflective glass that does not give off any glare or reflection at all. There is also laminated, shatterproof glass that will not damage the paper if it is broken — a good choice for very valuable pieces. All these factors have to be considered in your choice for any particular artwork based again on the value of the work, your motives, and your budget.

For those pieces that just wouldn't look right with a mat surrounding them, professional framers take measures to keep the work of art away from the framed piece of glass. You do not want any work of art to be directly touching the glass on a frame. Condensation, dirt, dust, and tiny particles can build up and adhere to the glass in your frame. This could result in damage to the work of art. Framers add spacers, which are usually little plastic elements that are placed between the art and the frame to provide a small gap between the work of art and the glass so the work of art doesn't touch the frame or the glass. The result is that the work on paper looks as if it is floating in the frame. This is a desirable framing method for many contemporary works of art.

Make sure you ask the framer to preserve all the original notes, gallery labels, and markings that are on the original framing. These can help establish provenance and add to the allure and historical value of the painting.

A final word on framing: the choices a framer presents you with all have benefits and price points attached to them. A conscientious framer will explain these to you, but in the end you have to decide to what degree you want to adorn the picture and to what degree you are prepared to ensure that it is preserved for future generations.

Conservation

Paintings can be the most expensive possessions that you own, and, like everything else, they are in a constant state of disintegration. There are,

however, many precautions you can take to slow down this process and to preserve your art, if not for eternity then at least for as long as possible.

"Humidity, particularly, is perhaps the most significant challenge for the well-being of a work of art in a country like Canada, where summer and winter temperatures differ so significantly," says art restorer Jerzy Nanowski. "Art does not react well to vast changes in temperature or humidity. The gesso used in oil painting often contains water-based glue which, when activated by the moisture in humid air, can cause the canvas to swell and shrink."[30] To help maintain your art, try to avoid excess dryness or humidity, exposure to direct sunlight, and temperature extremes. Paintings generally do well in temperatures between seventy and seventy-five degrees Fahrenheit, with relative humidity between 40 and 60 percent. An ideal environment, such as a museum or public gallery, will have minimal fluctuations in humidity and temperature. Limit exposure to smoke from fireplaces, stoves, and especially tobacco. You should inspect your art closely from time to time to make sure no problems are developing such as mould, mildew, cracking, or any other adverse conditions.

In summary, with works on paper, the best conservation advice is to use UV-protected glass, along with acid-free, 100 percent rag board backing and archival paper, and keep them out of any direct sunlight. I have seen the results of sunlight over time on many watercolours: they become washed out and faded with all the original colour and life vanished. Once they are in this condition, no restorer can bring them back to life. Only a skilled framer with conservation knowledge and experience can give you the choices needed to protect your art.

Restoration

While conservation is aimed at preservation, which is like regular maintenance on your car to give it a longer life and prevent problems before they happen, restoration is more like doing a major overhaul to your engine, for the purpose of bringing your car back up to its original condition.

Throughout the centuries, artwork has been constantly exposed to many unfriendly environmental enemies. Just imagine all the soot that was produced by the oil-burning lamps that were used from ancient

times until Edison's invention of the electric light bulb just over one hundred years ago. Central heating, air conditioning, and humidity controls are also only recent additions to internal atmospheric monitoring. It is, therefore, not surprising that many older paintings look gloomy and yellowed with age. Paintings deteriorate under the pressures of age and harsh environments by flaking, cracking, splitting, and drying out.

The art of restoration is a painstaking, labour-intensive process that combines the extreme care of a surgeon with the latest state-of-the-art technologies. When I was attending art history classes at the University of Toronto, I found it fascinating to see X-ray slides of many famous paintings that showed the over-painting and revisions that the artist or others had made. Today restorers use infrared spectroscopy to determine the chemical makeup of a painting based on the fact that chemical bonds of different molecules absorb infrared radiation in different ways. Computers can map every square inch of a painting, and restorers can then superimpose one image of the work over the original or copy to see what differences there are and what changes have been made, indicating to them what areas need restoration.

In the fall of 2004 the Centre de recherche et de restauration des musées de France and the National Research Council of Canada undertook an intensive study of the Mona Lisa. The NRC scanned it with a sophisticated 3D laser scanner that is capable of scanning at an incredible depth resolution of ten micrometers, or one-tenth of the width of a human hair. The 3D model of the painting was used to document and precisely measure the exact shape of the irregular panel, to examine all the surface features, to ascertain the state of conservation, and to study Leonardo da Vinci's techniques. In general, they found the panel to be in good shape, a split in the top half of the painting to be stable, and the adhesion of the paint to the surface to be good considering that it is more than five hundred years old and has been stolen, poorly reframed, and vandalized during its long and fabled history. Interestingly, all this technology could not reveal exactly how Leonardo painted the picture; the technique he used, called *sfumato*, or "smoked," remains a mystery. The state-of-the-art technology of the NRC has also been used on Michelangelo's statute of David, paintings by Renoir, Corot, and Tom Thomson, and Bill Reid's Haida sculptures.

Canada has one of the most advanced institutes for restoration, the Canadian Conservation Institute in Ottawa (CCI), a part of the Department of Canadian Heritage. It was created in 1972 to promote the proper care and preservation of Canada's cultural heritage and to advance the practice, science, and technology of conservation. It boasts "well-equipped, fully secure, climate-controlled laboratories, conservators, chemists, engineers, biologists, and other professionals [who] handle projects ranging from information inquiries to complex treatments and research."[31] The institute has treated more than thirteen thousand objects for conservation and responds to at least two thousand requests from cultural institutions annually for advice on conservation and restoration issues. It does not perform restoration on artworks from private individuals and will only advise them on an informal basis and recommend a list of professional private conservators who can actually complete the restoration work.

Severe damage to paintings can be caused by improper and harmful restoration techniques. Most old paintings have been restored in one way or another. Varnish that has deteriorated, discoloured, or been poorly applied; improper retouching and over-painting using irreversible materials; old patches and tears; and unstable linings are a few examples of the ravages of time. Harsh chemicals were sometimes applied to remove the top layers of varnish, but they also damaged the original paint surface below. Painting restoration has evolved over the years with the use of non-destructive methods and reversible materials. The most common treatments include surface cleanings and varnish removals with solutions mixed specifically for each type of surface grime and varnish, giving the painting a more vivid and brilliant appearance. In-painting is the restoration process whereby tears, punctures, scratches, and missing paint are filled with filler and painted over with the most suitable paint. Once the surface is finished and restored, a new varnish is chosen to the specifications of each painting, further protecting the surface for the future with added UV inhibitors and giving it an overall superior appearance. All of these processes are done meticulously, one tiny section at a time, until the whole painting is brought back to life, as close as possible to the way it looked when first painted.

Whether to keep the original frame, restore it, or replace it is a major consideration with all restorations. If the original frame works with the picture and was of superior quality to begin with, it might be best to restore it if possible. Many artists, however, were on a shoestring budget early in their careers and their choice of frames reflects that impoverished state. Of course, besides the frame, the conservation of the backing has to be taken into account even more so. Historically, when a frame was commissioned for an individual painting, its cost was often equal to or more than the painting itself. Over time, most of these frames were damaged by amateur repairs, painting over gold leaf, stressful environmental conditions, etc. Cleaning, paint removal, structural and ornament repair, casting, gilding, and refinishing can be done. Restoration of the original frame of a historical piece keeps the two original parts together and intact, thereby adding to the historical accuracy of the piece. After all, every collector is preserving history for future generations, so in my opinion the closer to the original, the better.

The services of a skilled restoration expert with a fine reputation will be expensive, and these costs have to be considered in relationship to the value of the painting. Damage to a painting will seriously affect its value. Just keep in mind that a damaged painting that has not been restored is always more valuable than a damaged painting that has been poorly restored.

Over the years, I have had many paintings restored and the results have been nothing short of astounding. One mid-nineteenth-century oil painting called *Two Terriers at Play* by British artist Martin Theodore Ward (1799–1874) was dark, ripped, and had been falsely signed as a Landseer (British painter, 1801–1873). The restorer opened up the picture about two inches all around, revealed details of the barn that had been hidden, completely repaired the two-inch hole so that you could not tell it had ever existed, and revealed the proper signature while erasing the forged one. I then took it to Emmett's Framing in Toronto, and he was able to come up with a perfectly fitted antique frame that suited the picture's time period, size, and style. Another time, I took a chance at an auction on a full-size (thirty by twenty-two) Doris McCarthy watercolour of Grise Fiord that was covered with foxing, which can be evidence of acid damage, and a lot of black mould. I was amazed when

the restorer was able to remove all of this crud and restore the picture to its original condition, even though it was a rather fragile work on paper.

I have had many other pieces cleaned and restored over the years and I am constantly amazed at the difference it can make to a painting. To aid your search for a good restorer, you might start with the Canadian Association of Professional Conservators' website, www.capc-acrp.ca. To be a member of CAPC, a conservator must have a minimum of six years of experience in conservation, including training and practice, or at least three years of conservation practice after graduation from a college or university conservation training program, amongst other requirements. You have to use the same criteria to find a conservator that you use to find a good framer. In fact, when you find a good framer, they will most likely be able to suggest a professional restorer, as they often work very closely together.

Decoration

This section deals with where to display and how to light artwork to its best advantage and how to handle, store, and transport it safely.

The following is a job description for a professional curator:

- recommends the acquisition of paintings, photographs, sculptures, documents, and other museum and art gallery artifacts;
- researches origins and artistic history of artifacts;
- develops storylines and themes and organizes displays and exhibitions;
- coordinates the storage of collections and setting-up of displays and exhibitions; and
- oversees the conservation, display, and circulation of collections.

Whether you are using art to decorate your home or your office, you are, in effect, acting as your own curator when you take on the job of purchasing, displaying, lighting, preserving, moving, and caring for your art.[32] Your first decision should be which works of art go where to best show them off and complement the surroundings. If you have the talent or inclination, you can hang, arrange, and install your art yourself, or you

can hire a professional art installer or interior designer to do it for you. Many professionals complain that they see paintings hung about six inches too high by amateurs. Consider the eye-level view from different positions in the room. Is the art going to be mostly viewed from a seated or a standing position? Consider the size of the painting and the space you are trying to adorn. There are no firm rules to this; within reason, great art adds beauty and intrigue to any environment. Make sure, however, that there is sufficient space to properly frame the painting. As artist Frank Stella said, "But, after all, the aim of art is to create space — space that is not compromised by decoration or illustration, space within which the subjects of painting can live."

You have to decide what feels right for you and your space. Some people like their walls covered in art, almost from top to bottom, in the European style, while most prefer a centred, very balanced arrangement of art. Personally, when I see any sizable area of blank wall space, I immediately start thinking about which painting would look good in that space. You have to plan your layout of pictures in relationship to the length and height of the wall and the depth of the viewing space away from the wall. Generally, you want to give large paintings room to breathe, while smaller works can be grouped together to form interesting arrangements and contrasts. You want to create unity within the group but not necessarily uniformity. You should also consider the top or bottom line of each painting — do you want them all to be at the same height from the top or lined up at the bottom regardless of their height or length, or do you want each painting to have its own space without relation to the others?

Another possibility is thematic arrangements of similar periods, styles, artists, mediums, or framing, to name just a few. A mixture of old and modern can work very well on one wall or in one room; try a different mix for each room or floor. A developing trend, which when done well looks striking, is to place antiques side by side with contemporary artworks. The contrast can be dramatic and highlight the best of both. For me, the ideal arrangement is one in which the space and the picture (or pictures) complement one another in perfect harmony. Then again, as a Libra I always want everything to be symmetrically balanced. Someone once said, "You should never trust an art dealer who can sit in

a room for more than ten minutes with a crooked picture." I know I can't! The truth is, however, that there are endless possibilities that can deliver a pleasing effect.

Another very important consideration is the type and direction of the lighting. With fine art even a slight difference in direction or type of light (fluorescent, incandescent, halogen, natural, etc.) can make all the difference. Incandescent lights, which produce illumination by the heat resistance to the electrical current, have their good and bad points. They bring out the warm hues of the colour spectrum (the red, brown, orange, and yellow tones), but the cool colours (the blue and green tones) will be flattened. Fluorescent lights are not ideal, as they give off a high amount of harmful UV rays. They also do not emit light across the entire colour spectrum, which can distort the true colours of any painting.

The solution, for most applications, is to use a properly installed low-wattage halogen light source. But be careful not to have the light source too near the piece and not to shine a strong light directly on any painting for an extended length of time, especially if it is a work on paper. If possible, it is better to use indirect or recessed lighting to illuminate paintings. Be careful not to over-light them on the wall and cause them to stand out to an extreme. You'll notice that in most public art displays the lighting is indirect yet luminous.

A final important point to consider on this subject is that no matter how well you hang, arrange, and light your artworks, eventually your eye will get used to them in a particular spot. You'll need to completely change things around from time to time to rediscover their sparkle. Most professionals suggest changing the placement of your art at least every two years. I know what an effort it takes to hang them perfectly and how good you think they look right where they are, but you will be amazed by how fresh and exciting the same paintings can look on a different wall or combined with new paintings. And if you have enough art that you can rotate your whole art collection from year to year, even putting some away in storage for a time, so much the better. I read about collectors in Miami who invite a local curator over to their house every year and give him free rein to curate a new "show" inside their house simply by rearranging their old and new artworks as they would hang a new installation. Very exciting! It is easy to become complacent and just

place everything where you think it fits best and then leave it there for years, but be courageous and shake things up and you will be amazed by how the artwork and you adjust to the new arrangements.

Handling, Shipping, and Storage

I suppose that everyone has heard by now how Steve Wynn, the owner of the Wynn Hotel in Las Vegas and one of the greatest art collectors in the world, damaged his Picasso painting *La Rêve* by putting his elbow through it, thereby cancelling a pending $139-million sale for the painting. Apparently his response was, "Oh shit, look what I have done. Thank goodness it was me!" Nevertheless, mishandling valuable pieces of art can be very costly indeed.

I have been in the moving and storage business for almost thirty-five years and have packed, shipped, and stored many valuable pieces of art from the homes of executives across the country and around the world. Special packing, handling, and transportation for expensive artworks has to be considered at all stages of the journey. My first real experience in transporting valuable — actually, priceless — art was when my company handled the shipping for the King Tut exhibit for the Art Gallery of Ontario in 1978. Actually, all we did was move the cases from the plane to the AGO in our trucks, but for years we advertised "We Moved the Treasures of a King" next to picture of King Tut's golden mask. Each precious object was packed in a custom metal suitcase with the exact outline of each piece fitted in foam and lined inside with deep blue velvet. In my humble opinion, King Tut's golden funerary mask is the single most beautiful piece of artwork ever created by humans in all of recorded history. The memory of seeing it for the first time is with me to this day. I understand that they are not going to allow it to leave Egypt ever again, so you will have to visit the Egyptian Museum in Cairo to see it in person. Just to see that mask alone is worth the trip, although the rest of Egypt is full of spectacular, breathtaking antiquities and art.

If you have valuable art to move and/or store you should be using the services of a specialized art handler rather than a normal household goods mover. Art is most vulnerable to damage and theft when it is

being transported. The most important initial consideration is the crating and packaging of the art. There are many new and secure methods of packaging artworks available, and which one you use might depend on the costs and on your insurance policy requirements. The options range from a basic plywood crate with foam surrounding the insides to a custom crate with pine battens, lined with foam, and with a neoprene gasket to seal the lid with specially engineered bolt plates. Some experts use a digital image of the object to carve a form-fitting foam cushion inside the shipping crate similar to what was used for the King Tut exhibition pieces. Bar codes should be used to keep track of the crates and "shock clocks" should be attached to the outside to record any significant jolts to the crate during transport. Building a crate within a crate can add a good measure of extra protection in extreme cases. Finally, allow your artwork to settle for a few days before you attempt to move it or install it, especially if there has been a significant change in temperature or humidity from its origin to its destination.

Even if the artwork is shipped immediately, it is likely to be placed in the transport company's storage facility at some point in the moving process. It is essential that the storage facility be safe and secure. How are the facility's fire safety ratings, early warning smoke detection systems, personnel screening and training, inventory controls, and lighting and environmental systems?

You must then ensure that your artwork will be securely transported on air-ride vans with internal non-abrasive equipment to properly secure the artwork to the truck or container. Finally, make sure that the artwork will fit through the door or in the elevator, or, as a last resort, have enough access for a crane to be able to hoist it safely through an opening in the roof or a removed window when it arrives at its destination.

Along with having adequate insurance coverage, which is discussed in detail in Chapter 12: Theft, Scams, Insurance, and Copyright, these are some of the many factors to be considered before entrusting your valuable art to a third party. Ask the proper questions before assuming that everything will be handled up to your standards and the requirements of your insurance company. Precious art can never be replaced, so do your homework before you act. As the old proverb states, an ounce of prevention is worth a pound of cure.

Do you remember how the ossuary for James, the brother of Jesus, was shipped to the Royal Ontario Museum for its exhibition in late 2002? It was wrapped in shrink wrap over old cardboard boxes like a carton of used clothing! It, of course, did not make the journey intact. It developed a major crack right through the most significant historical writings. Considering how it was packaged, it is a wonder that it only cracked. It was, however, insured for a reported $2 million. Maybe the owner knew something about that box that we didn't know! (There is still controversy over whether the ossuary is a fake or not, with most experts coming down strongly on the side of its being a fake.) This is not the only artwork or relic of antiquity whose veracity has been challenged; in fact, the art world is filled with them. How to identify a fraud, a fake, or a forgery is the topic of our next chapter.

CHAPTER 4

Fakes, Frauds, and Forgeries

*"There are two kinds of people in society, those
who trick others and ... others."*
— antique forger Andre Mailfert, 1910[33]

Because the art market involves trade in objects that are often worth substantial amounts of money, there are always people who will find a way to cheat, lie, or steal to get some of that money fraudulently for themselves. Unfortunately, this has been a constant problem in the history of the art market. This chapter will help you to avoid becoming a victim of either the professionals who make a living at forgeries or the innocent or not-so-innocent players in the art market who pass on fakes as originals. Regardless of the intentions of the individual or company, you do not want to pay money for an artwork that is not what it appears to be or, even worse, become part of a chain of people who unknowingly pass on a forgery. In the art market the saying *caveat emptor* is very much alive and well and should be kept close in mind.

A Brief History of Forgery

Artists have been copying the images and styles of other artists for thousands of years. Surprisingly, only a few original Greek stone sculptures have survived, so our impression of the works of the sublime Greek geniuses of the fifth and fourth centuries B.C. is in reality based on ungainly Roman copies, most churned out by second-raters.[34]

During the Middle Ages, up until the time of the Renaissance, it was common practice to copy works of art as a means of preserving them for future generations. The purpose of art was either religious or historical, and the identity or reputation of the artist was of little importance. Copying works of the masters was a normal part of any artist's academic training and, in fact, in many modern art schools it is still a required part of the curriculum. In the sixteenth and seventeenth centuries, new wealth and the formation of a prosperous middle class eventually led to the creation of a secondary market, consisting of consumers, dealers, galleries, and auction houses. Some criterion for judging the monetary value of all this art was needed, and the most readily available one was the identity of the artist. First, this took the form of an identifying mark on the work, and later on, a signature. As the demand for fine art far exceeded the supply, misuse of these marks and signatures became rampant. Controlling legislation was enacted, as it always is whenever commerce enters the picture, and the formerly respected tradition of copying art became art forgery.[35]

For the first time in history, art became a commercial commodity, and with that development came the opportunity for unfair profit by means of fakes, forgeries, and fraud. From the time when forgeries had a ready and expanding market, the list of artists who were copied and the skills of forgers grew in tandem. A considerable array of Renaissance works of art was faked in the sixteenth and seventeenth centuries. These forgeries are nearly impossible to detect, since they are now far closer in time to the date the originals were created than they are to the present.

Artists themselves also made copies of their own most popular works to boost sales. El Greco (1541–1614) listed at his death as many as five or six versions of his most noteworthy originals, all of differing sizes, all of which the master could not have painted himself. They sold and still sell today as originals.[36] Some of the supposed fakes of Claude Monet (1840–1926) are in fact his own near-replicas of his own compositions. He is known to have placed ads in local French newspapers in the late nineteenth century offering for sale works of haystacks, poplars, and the façade of Rouen Cathedral that he guaranteed to make different by changing the light and shading. Renoir made and sold many lacklustre copies of what he thought were his best pieces.[37] We must keep in

mind that many artists did what they had to do to survive, and their art, for the vast majority, was not highly valued in their day, and so they copied their more popular subjects and paintings to make a living.

Besides the copies the artists made themselves, there are many notable forgers who copy the works of famous artists in such great quantities and with such artistic skill that it has been estimated that over 15 percent of all the paintings sold in the world are fakes.[38] Some of the most infamous forgers include the Dutch painter Hans van Meegeren (1889–1947), who was arguably the best-known forger of the twentieth century. In all, Van Meegeren is now recognized by experts to have painted fourteen forgeries of Johannes Vermeer works. He also created fakes of works by Pieter de Hooch, several of which had been proclaimed masterpieces by scholars before it was learned that they were spurious.[39] A Hungarian forger named Elmyr de Hory (1906–1976) was a most prolific and versatile forger, faking works by important artists including Picasso, Renoir, Modigliani, Matisse, Vlaminck, Derain, and Dufy and fooling art galleries around the world for more than twenty years. Between 1961 and 1967 alone he claimed to have forged $US60 million worth of paintings, which he sold to art galleries and Texan oil millionaires. As much as 90 percent of his forgeries are still hanging undetected in museums and galleries, according to his biographer, Clifford Irving.[40]

In the sixties forgers became busier than ever with the rising fame and prices of Picasso, Braque, Matisse, Dali, Miró, Matisse, and Dufy, to name a few. Forgers David Stein and Canadian Réal Lessard worked for an agent named Fernand Legros, who allegedly sold their forgeries with fake certificates. (Just consider how easy it would be for an accomplished forger who has the skills to fool the experts with copies of world-famous pictures to forge a history of provenance or a certificate of authenticity!) David Stein was such a skilled forger that, according to legend, he managed to have a forged Picasso authenticated by Picasso himself!

Canadian Art Forgeries

Until recently, Canadian art has not attained the values that would warrant an extensive network of forgeries of individual paintings, but there have been some notable exceptions, principally involving the works of

Tom Thomson and Cornelius Krieghoff. Forgeries and frauds will continue to proliferate as the prices of Canadian art escalate, and not only for the biggest names in Canadian art but also, increasingly, for the lesser known artists where slight modifications are less easily noticed. Many of the Group of Seven artists and Maud Lewis, William Goodridge Roberts, and Norval Morriseau, among others, have either been copied or had fake signatures added to unsigned works that give them an apparent stamp of authenticity. The market for Inuit prints and soapstone carvings is rampant with forgeries. Even prestigious auction houses have been fooled, and with the increasing presence of eBay and online auctions, the opportunities to put dubious or fraudulent art in play have increased dramatically.

Years ago, I purchased a beautiful charcoal pastel of a young female nude, dated 1915 and signed by Suzor-Coté, from an auction at Joyner Waddington's. Some time later Laurier Lacroix, the leading expert on Suzor-Coté, raised doubts about the authenticity of the piece. When I told Geoffrey Joyner, the president of Joyner's at the time, about Mr. Lacroix's doubts, he, without hesitation, refunded the purchase price.

So, fakes and frauds do occur from time to time in the Canadian art market, but for now they are mostly limited to forged signatures added to imitations rather than copies of famous paintings.

The Most Common Frauds: Copies and Reproductions

For Canadians art consumers, the art that is the most susceptible to fraud is in the print market. This involves mostly the selling of reproductions as originals, often with forged or stamped signatures, using various important-sounding art terms, and then accompanying the piece with worthless certificates of authenticity and giving purchasers expectations of substantial future appreciation. I covered this kind of deception in Chapter 2: Demystifying Art Terminology, but it bears repeating. There is nothing wrong with selling a reproduction of a famous painting or print as long as there is no attempt to represent it as more than it is and the price is in line with its real value. Purchasing original prints is a legitimate way to own fine pieces of artwork by great artists whose original

paintings are beyond the financial means of most people. However, the market even for these original prints by international artists such as Miró, Picasso, Chagall, and others has gone through the roof and they too can be very expensive. This is where unscrupulous scam artists prey on the greedy and the unsuspecting, reproducing these prints by various means and passing them off as originals.

Fraud enters into the sale of restrikes (impressions made from original templates after the artist's first impressions were printed, also called "late impressions") when the quality and rarity of a print is misrepresented. Some corrupt merchants buy restrikes cheaply in large quantities, cut off the museum's identification stamp, forge numbering notations and artists' signatures on the prints, and sell them for hundreds of dollars each, representing them as part of a rare limited edition. More enterprising print merchants have even tried, with some success, to "uncancel" cancelled etching and engraving plates by removing the scored lines and printing new impressions, which are priced and sold as if they were from the original limited edition. It is often difficult for the untrained eye of the average print collector to identify a restrike, unless an early impression of the image is available for comparison.[41] Another common technique of print forgers is to remove unsigned original lithographs by famous artists from books, magazines, or portfolios and then sign them and pass them off as signed original prints.

Original prints made by artists are usually printed in editions of less than one hundred and rarely more than two hundred. When original prints are produced, the artist approves each print as it is printed and signs it by hand. The prints are numbered according to the accurate total number of prints in the edition. Then the template is destroyed. On the other hand, photo-mechanical reproductions (also confusingly referred to as prints) are usually printed on offset printing presses, in editions of at least three to five hundred and occasionally in excess of fifty thousand! There has been great deal of controversy in the Canadian market over the marketing of numbered and signed "prints" by Robert Bateman, A.J. Casson and other members of the Group of Seven, Trish Romance, and others artists in huge editions, sometimes up to fifteen thousand. These prints, although they may be signed and have all sorts of official stickers and certifications on them, are really, in most cases,

no more than offset printing reproductions. The presence of a facsimile signature, an estate stamp, or the manual signature of a relative of the artist on a print adds little to its value and should therefore not be interpreted as a guarantee that the impression is authentic or original.[42]

These reproductions are not considered long-term investment pieces unless there is a collectors market of the artist's fans who buy and sell amongst themselves. Most reproduction art will never appreciate significantly. Any advice to the contrary is misleading and very likely financially motivated by the seller. I have seen many of these prints come up for auction in the aftermarket and sell in the hundreds of dollars, often for less than the cost of the frame, which can come as a severe shock to those who paid thousands of dollars for them in the first place.

Protecting Yourself from Fakes, Frauds, and Forgeries

The first rule in avoiding becoming a victim of fraud is to know everything there is to know about the particular artist and the art period you are thinking about investing in. While this book can give you a number of general areas to look at, nothing can replace first-hand expert knowledge and research. Nearly all art lovers continually add to their knowledge and insight into the artists and art periods that they love. As your appreciation and affection grow, so does your understanding of all the details that may be overlooked by a less informed person, making you a less likely target for a huckster. There are, however, more intensive procedures available to further prove the veracity of any artwork.

An adequate information base will help you to identify artists' correct and acceptable signatures, their usual and preferred mediums, their evolving styles, their important dates, their characteristic brushwork, and their preferred themes and subject matter. Most accomplished artists have a technique and style that is so unique to them that almost all their paintings can be readily discerned by a trained eye. So when a painting appears on the scene that is questionable, before all the regular factors have been accounted for, the undeniable X factor that all art appraisers rely on kicks in — an inner voice or intuition that tells them something is wrong. When this alarm goes off, listen to it! It is often the little details and overall look

and feel of the painting that seem out of place. Great artists are revered because they have remarkable and rare talent that is almost impossible to duplicate. Most forgeries are woefully lacking in that creative spark and presence that typifies the artist's real work. The Tom Thomson forgeries mentioned above were almost laughable in their ineptitude and lack of artistic merit. The problem is that all artists, even the great ones, produce some inferior pieces that don't truly represent their talent, but generally, even with a lesser work, the stamp of the artist's originality and particular style somehow manages to shine through. I know that with my love and understanding of the art of Doris McCarthy, I can usually identify an original from a long way away. With my knowledge of her life's events I can even place her art close to where she was travelling at the time or what period of artistic style she was following. One or two unsigned works of hers from the thirties have appeared that were questionable, and I knew enough to steer clear of them.

If the basic identifying criteria are all there and there are still some doubts about the authenticity of an artwork, then you may have to investigate more fully. Ask for it to be removed from its frame and examined under a UV light, which will reveal any restoration work, added signatures, and other problems.[43] This will also reveal the condition of the frame, whether it is old or new, and show any inconsistencies or manipulations that may have been done to make the frame appear older than it is. New stretcher bars on old canvases might be an indication that a forger is at work trying to alter the painting's identity. Finally, forensic and scientific analysis, such as various forms of X-rays and carbon dating used to measure the age of an object up to ten thousand years old and white lead dating used to pinpoint the age of an object up to sixteen hundred years old, can almost always reveal a forgery. Finally, there is a new technology that some artists are using to tag art called Smart Mark, where a sample of the artist's DNA is mixed with invisible paint and applied at a predetermined spot on the canvas that is kept on record with the artist for any future need of verification. As Freemanart, a company that specializes in detecting fakes, says on its website, "A good forger attempts to deceive the naked human eye. It's part of the challenge in the game he plays. Deceiving science in expert hands is, however, practically impossible!"

One of the simplest ways to test the authenticity of a print is to examine it under at least a 30x power magnifying glass. If the signature and image were reproduced by photo-offset printing, a close inspection may reveal the halftone screen dot pattern. All printed and stamped signatures have a flat, uniform appearance and do not shine as most authentic pencil signatures do when examined at eye level under a light. But that is just a start in eliminating the fakes, as the more sophisticated fakes are not copied on an offset press and therefore will not show the screen dot patterns under a magnifying glass.

Another way to check if a print or original art is authentic is to compare it against the information in the artist's catalogue raisonné (CR), if there is one. The CR is a comprehensive listing of an artist's entire work, or work in a particular medium, with entries presented in chronological order. Details can vary, but generally they include the date of the work, its size, medium, subject, condition, provenance, attribution, and last known location.[44] With prints, a CR will give often give the quantity of an edition, size of the prints, the type of paper it was printed on, and examples of the placement and facsimiles of the signature. The paper on which a print is printed can also offer clues about its authenticity. The identification of the manufacturer's watermark is of the utmost importance, and the absence of the correct watermark is an absolute giveaway that the print is a fake.[45] Unfortunately, the opposite is not true, as expert forgers will not only use the correct paper but also reproduce the watermark used on the originals. If you are not confident in your own ability to detect a fraud, it would be money well spent to have a professional appraisal done before you commit to purchase, especially if a significant amount of money is at stake.

According to Freemanart Inc., many prints that they expose as fakes are supposedly by renowned international artists Salvador Dali, Pablo Picasso, Marc Chagall, and Joan Miró. You should especially not buy prints by these or other famous artists as originals from anyone who will not give you a written guarantee of authenticity. A reliable seller will have the history, reputation, and willingness to stand behind the sale, along with a complete money-back guarantee. This would definitely eliminate cruise ships, hotel ballrooms, travelling auctions, and any other temporary venues. Only established art and print dealers will give

you the guarantees you need to be sure you are receiving what you are being told you are buying. Most art beyond these reputable venues is sold "as is," and it is the responsibility of purchasers to make sure what they are buying is real. Buying from a dealer or an auction house that has been in business for a long time and will stand behind whatever it sells is the best prevention against being a victim of fraud. (See Chapter 7: The Smart Guide to Auctions for more information.)

In Summary

With regards to fakes, forgeries, and frauds there are two basic things to keep in mind. First, unless a historical work has been thoroughly tested and authenticated by impartial experts, there is some risk that it is not what the seller says it is. It's a bit like fatherhood — no matter how sure you are, unless it is proven scientifically, it is always somewhat presumptive! That means that even though a work is signed, has a good provenance, and looks how it should look, until it is independently authenticated there is always some doubt. Forgers, like counterfeiters of any kind, are always working to improve their game and stay one step ahead of detection. Impressive nameplates, dedications from the artist, clear signatures, and important previous owners can all be convincingly forged. Forgers will not allow you the time you would need to get verification, claiming that they don't have time to wait or insisting that the art has been handed down in their families or that it was purchased directly from the artist. They distract you from normal research procedures by making you think you're getting a great bargain. They tell you they have other buyers just waiting to buy if you don't act quickly. They may claim to be reputable and established dealers who have been in business for many years. Thomas Hoving, former director of the New York Metropolitan Museum of Art, summed it up when he said, "The forger's best friends are greed, speed and need."[46]

The second thing to keep in mind is that just because the seller believes a piece to be real does not make it so. He might have believed the story of the person or institution he purchased it from, but that does not make it true. Not everyone has the time or resources to check out all the

facts as they are presented; in fact, most simply accept the seller's word because it is too difficult and expensive to have technical and historical analyses done on every piece. Can you imagine every dealer and auction house going to the trouble to have each piece independently tested and approved? Thousands of pieces go through their showrooms every day and mistakes are often made in both directions. Listen to sellers' stories of how they acquired the work themselves. Was it was from first-hand knowledge of the artist or second-hand from any number of secondary sources? Auction houses have historically been favoured venues for forgers to dispose of their works or for dealers to place their items that have less than stellar qualifications. I have seen a number of misappropriations at auctions, often confusing two similarly named artists or attributing the work to an artist with little or no proof. Finally, the world of online auctions and eBay puts another layer of distance and accountability between the buyer and the seller, and purchasers should be exceedingly cautious when buying artwork, especially prints, in this marketplace.

SECTION 2:
OUTSIDE THE FRAME

CHAPTER 5

The Intricate World
of Art and Money

*"As in most arranged marriages, the unnatural union of
art and money has found a modus operandi that ensures
a general equilibrium for the family of the art market.
And, as in many arranged marriages, conflicts of interest
and differences of opinion lead to abuse and other
violent reactions."*[47]
— Judith Benhamou-Huet, *The Worth of Art*

In the world of art we must reconcile the sacred (the higher spiritual
nature of humankind to which all true art appeals) with the profane
(the money, profits, and egotism of the art market). You may think of
great works of art such as the Mona Lisa or the Venus de Milo as so
treasured that they couldn't possibly have a monetary value — that they
are, in all senses of the word, priceless. However, all works of art, hum-
ble and great, also exist in the material world; they must be assigned a
monetary value so they can be insured and, yes, bought and sold.
Ultimately, art — like real estate or fine cuisine — is worth whatever
someone is willing to pay for it. The sacred and profane have to be rec-
onciled within the world of the art market: "History and scholarship
single out certain artists for veneration, and the art market expresses
this judgment in terms of money."[48]

Anyone who has glanced at the price list discreetly placed on the
receptionist's desk at a commercial art gallery has probably gasped in
shock. How, one might wonder, can a single oil painting by a reputable
but not world-famous artist cost so many thousands of dollars? Art is

not the same as other commodities and its price cannot be figured solely in terms of practical considerations such as the cost of materials, how many hours the artist spent making the painting, and so on. One oil painting may take several years for an artist to complete, or it may be done in a day. Art journalist Judith Benhamou-Huet explains, "Expensive art can be good or bad. Cheap art can be execrable or excellent. Money justice and art justice are two separate things. But, at the same time, the art market is no doubt having its say about the fundamental question of the definition of art."[49]

For many people art is not about the intrinsic beauty or the historical significance of the artwork but the investment potential of the piece and how much they can eventually profit from it sometime in the future. There always seems to be a parallel discussion going on, or at least an underlying subtext, that combines the inherent worthiness of the art in itself with its current or future price. The two subjects are inexorably intertwined. Since art, more than any other consumer item, can be priced vastly out of proportion to its actual cost and practical value, there must be a general agreement that it is worth what someone says it is. "But the real question here," Darian Leader writes, "is to ask where else in a civilization one can pay so much money for so little."[50] In the fantasy world of the art market, the concept of what constitutes a fair or reasonable price is sometimes a relative idea.

Within the art market, there is a subtle, unspoken distinction established between the art itself and the price of that art. Consider, as an example of the uniqueness of the selling of art, that many art dealers and art galleries do not display prices in an obvious manner, nor do they market their pictures with an emphasis on the sales or financing, although fine art can be as expensive as a car or a house. Prices are quoted in round numbers, and the sales, pricing, and financing are kept far in the background of the store, both literally and figuratively. It may seem that their only interest is to display the art and/or the artist for your appreciation. But the gallery, dealer, and artist all have to sell paintings to stay in business, and you have to purchase them in the same manner that you have to acquire any other commodity.

As discussed, the dealer's world seems to be disconnected from commerce, and yet without sales there would be no art business.

Conversely, unlike most dealers in fine art, auction houses focus solely on the selling and marketing of art and make little effort to disguise the fact that their sole purpose is to put on the market as much art as possible in the most efficient manner without regard to the artists or the effects on the art market in general.[51] Auction houses are direct sales outlets that act as agents between sellers and buyers, selling the art at whatever price is set by the market on the day the art is sold. In addition to these major players in the art market, there is the Internet, private and estate sales, art fairs, and of course the artists themselves. All of these comprise the mainstream of the art market.

In the art market there are also a number of middlemen, including consultants, agents, interior decorators, publicists, and others, who all have a stake in the business of art and who all take a piece of the final realized price. Artist and collector Marques Vickers writes, "In traditional business distribution terms, the artist is the manufacturer; the gallery is the retailer, and the buyer the ultimate consumer."[52] The bottom line is that all of these players are trying to market and sell art but approach it from very different motives and with extremely different points of view.

Fine art is a luxury item with many of the same market considerations that apply to other high-end possessions. Art buyers are concerned not only with the pleasure they receive from looking at their art (aesthetic value) but also with the understanding of it as an investment (economic value) and with the status they receive from owning it (social value). For Benhamou-Huet, a work of art has an intrinsic value quite apart from the usual measures of worth: "It is a symbol of freedom, a mental disposition, a transcription of the soul, an encapsulation of all that is most noble in man."[53]

Many of the same economic forces that govern the stock market also govern the art market. The law of supply and demand influences prices, as do less tangible forces that either give the market the confidence and strength necessary to expand or take it away and cause it to shrink and pull back. As a society, we place immense value on the kind of exquisite talent and originality that the vast majority of us do not possess, and for the most part the small number of works of art that survive the tests of time and taste represent a commodity that is rare and

precious indeed. Benhamou-Huet says, "Art does not follow 'taste' or culture. As [British performance artists] Gilbert and George would say, art follows money."[54]

While most fine art is exchanged through dealers or auction houses, art also changes hands on the Internet, at private and estate sales, at art fairs, and at artists' studios. To invest in art wisely, you will have to understand how these different markets operate and the advantages and disadvantages of each. In the following chapters, we will take close look at all of these different ways to purchase fine art.

CHAPTER 6

Galleries and Art Dealers

"The art market revolves around hugely desirable, one of a kind objects whose value is in large measure a matter of opinion. The art world's upper echelons are a natural home for vanity, greed and envy. Moreover, the art market is a virtually unregulated, anything-goes bazaar."[55]
— Edward Dolnick, *The Rescue Artist*

Imagine that you are walking along the street, and in the window of a gallery you see a painting that captures your attention. You decide to go in for a better look. If you really like the painting, you may have an experience like the one artist Wassily Kandinsky described: "In the first place you receive a purely physical effect, namely the eye itself is enchanted by the beauty of color. You experience a satisfaction and delight, like a gourmet savoring a delicacy.... And so we come to the second result of looking at colors: their psychological effect. They produce a correspondent spiritual vibration.... Generally speaking, color directly influences the soul."[56]

If you're new to it, walking into a gallery to look at a painting can be an intimidating experience. Maybe you feel that you don't know enough about art to appreciate its true meaning, or perhaps you're worried that you'll be expected to buy something if you go inside. But don't worry, this chapter will help you understand exactly how galleries and dealers operate. This, combined with your new understanding of art terms (Chapter 2: Demystifying Art Terminology), will help you to feel confident when you push open that door.

Two Kinds of Galleries

The word *gallery* is used both for museums dedicated to the public viewing of art and for private galleries that display and sell art. Most public galleries exist to allow people to come, look, and learn about art, while most private galleries allow visitors to look, learn about, and buy the works on display. For example, the Art Gallery of Ontario in Toronto and the Masters Gallery in Calgary are both called galleries, but the first only allows you to look, while the second also allows you to buy. Sometimes, however, public art galleries also sell original art. Recently, I attended the opening of the newly renovated Art Gallery of Hamilton and was almost out the door when, at the end of a long hallway, a painting caught my eye. From a distance, I said to my guest, "Let's go see that painting over there. I think it's a Jackson Pollock." As we came closer, I noticed a price tag to the side of the painting and I thought that was very unusual for a gallery, especially as the price would be in the millions of dollars! (Try waiting for approval of that item on your AmEx platinum card!) It turned out to be an artwork for sale by a local artist named Francis Ward and I bought it. Not a Jackson Pollock, but a great painting nonetheless, and somewhat more affordable.

The first public art gallery was the Louvre, established in Paris in 1793 as a result of the French Revolution. For the first time, the public was able to see the vast collection of art that had been owned by the French royal family. Since then, public art galleries large and small have become common across the globe. Over the past several hundred years, commercial art galleries have also become widespread. Retail galleries evolved from selling individual canvases to promoting a limited number of artists and taking an active interest in furthering their careers. Almost all retail gallery owners are art dealers by definition, but some art dealers operate privately without galleries. (Since most art is sold through commercial galleries, we will use the terms *art dealer* and *dealer* to refer to gallery owners. I will discuss art consultants and private dealers later on.)

Until the turn of the century, most dealers in Canada sold art along with other goods in their stores. In 1842, the Roberts Gallery opened on Yonge Street in Toronto, and today it is the oldest existing fine art gallery in Canada. In Montreal, William Watson opened his own art business in

1905, selling the artworks of many now-famous Canadian painters, including J.W. Morrice, Maurice Cullen, Robert Pilot, Clarence Gagnon, Marc-Aurèle de Foy Suzor-Côté, and Cornelius Krieghoff. Among Canada's most celebrated dealers have been Avrom Isaacs of the Isaacs Gallery in Toronto, Max Stern of the Dominion Gallery in Montreal, and G. Blair Laing of the Laing Gallery in Toronto. Today, the most renowned art dealer in Canada is almost certainly David Loch. Loch is the owner of three galleries across Canada and was a friend and dealer to the late businessman and renowned art collector Ken Thomson. There are many other top-notch dealers from coast to coast, and in my experience they are extremely passionate about art and love to discuss any and all aspects of art at any time. As someone remarked, art dealers are either looking at art or talking about it.

My favourite art dealer of all time was Joseph Duveen, a bold and innovative entrepreneur who was born in England in 1862. Around the turn of the century, Duveen observed that Europe had all the art, while America had all the money, so he resolved to bring the two together. Duveen's clients included Henry Clay Frick, William Randolph Hearst, Henry E. Huntington, J.P. Morgan, Samuel H. Kress, Andrew Mellon, and John D. Rockefeller, and it was Duveen who was most responsible for the great collections now in America. It is quite remarkable to view the list of paintings that Duveen was responsible for selling that now form a major part of some of the best public collections in America. Duveen's biographer, playwright S.N. Behrman, writes, "In his five decades of selling in this country, Duveen, by amazing energy and audacity, transformed the American taste in art. The masterpieces he brought here have fetched up in a number of museums that, simply because they contain these masterpieces, rank among the greatest in the world. He not only educated the small group of collectors who were his clients but created a public for the finest works of the masters of paint-ing."[57] Duveen gave America's nouveaux riches the one thing they did not have — immortality. Through world-class collections of art, America's self-made men were able to preserve their legacies. Duveen himself became a generous philanthropist; he donated many paintings to the Tate Gallery in London and built the Duveen Gallery of the British Museum.

One way Duveen maintained his position was to make sure that no picture he bought or sold ever declined in price. He was constantly buying — or having his clients buy — Duveen pictures from the estates of customers in order to keep the market up.[58] Duveen's clients could die secure in the knowledge that as long as Duveen was alive their collections would never depreciate in value. Duveen said that this strategy showed how necessary it was to look at life through the right glasses, and it was his function to furnish his clients with the right glasses for looking at works of art.[59]

Without dealers, there would be no commercial spaces to display and sell art, but without artists, the galleries would have nothing to sell. Each needs the other to accomplish their goals from both an artistic and a fiscal perspective. The relationship between the artist and the gallery, although it has a long and rich history, is often misunderstood by the general art-buying public. As one art dealer said to me, "The hardest part of my business has been dealing with the artists. After all, they're artists and bit crazy." Let's examine the relationship between the artist and the gallery owner so we can better understand the dynamics between them and the impact it has on the marketing of art.

The Relationship between the Gallery and Artist

Artists track their professional growth by which galleries choose to represent their work; prestigious galleries cultivate their reputations based on the calibre of artists they sell and display. A gallery's reputation is significantly enhanced in the eyes of the artistic community if it is good at selling artwork by established artists or innovative up-and-comers in volume and at full retail price.

There are, without doubt, many more artists than there are galleries to represent them. Galleries exact a generous commission for their efforts, but a good gallery is worth every penny. Experienced dealers have the kind of access to buyers that most artists will never have. They can also sell artworks for prices that most artists would never dare ask.

The average dealer markup on a work sold by a gallery is typically 100 percent or more, meaning that the artist will receive half or less

of the retail price of his artwork. For emerging artists, those with few sales and few exposure opportunities in their past, the markup may be as high as 200 or 300 percent. But the advantages of gallery exposure are worth it.

Most artists are represented by a gallery by means of a formal contract or informal agreement that gives the gallery either exclusive representation within a certain region (geographical representation) or completely exclusive representation for a certain period of time. It may or may not prevent the artist from selling artwork from her own studio without sharing the proceeds with the gallery. Sometimes dealers will buy an artist's entire output or at least individual works to support her financially. On occasion, galleries have been known to pay artists a wage or draw against future sales to allow them to focus on their art without the need to seek outside employment.

A good dealer recognizes how important an artist's work is and how her current works fit into her career. He recognizes the strengths and weaknesses in the art and in the markets for that art. The dealer is also the artist's connection to a well-established list of clients and collectors who regularly purchase art. Selling her work through a gallery allows the artist to concentrate in her own mysterious and wonderful way on creating art while the dealer is assigned to do what he does best: marketing and selling the art. This is what the late artist E.J. Hughes (1913–2007) had to say about his relationship with his dealer, the legendary Max Stern of the Dominion Gallery in Montreal: "One of the things I like about our contract is that you have relieved me of a great deal of personal interviewing and corresponding, among other things, which allows me a lot more time for painting." I believe a great many artists feel this way. The dealers handle the business side, leaving the artists free to concentrate on their art and creativity.

Many dealers also sell art from the secondary market, meaning works that have been purchased from a source other than directly from the artist. The gallery may have purchased the artworks outright or they may be there on consignment from the current owner; in any case, the artist is not involved in the sale or the proceeds. The pricing will be based on rules for art on the secondary market and what that market will bear rather than on any revenue-sharing arrangement.

Richard Gray, president of the Art Dealers Association of America, says, "Money ... lubricates our market. And all the artists who have any kind of reputation, develop any kind of prominence, are able to finally make a living, sometimes a very good living, being artists."[60] Without a doubt, talented artists represented by prestigious galleries can earn a lot of money from the sale of their artwork.

The Price of Art

The price of art includes the costs of doing business. Many art dealers have to balance their love of art with the economic realities of running a commercial gallery with significant overhead, including many of the same expenses that other small businesses have: rent, utilities, insurance, security, advertising, computer equipment and services, storage, and catalogues. The dealer must cover the salaries of the staffers who, along with many other duties, have to pack and unpack the artworks, install them for exhibitions, pour the wine at openings, and help customers. To cover their costs, dealers frequently take as much as 40, 50, or even 60 percent of the price of every artwork they sell. Still, according to one estimate, 75 percent of all contemporary art galleries do not survive more than five years. Many owners will eventually make money on the gallery's real estate holdings, if they own the property.

The art business is populated with great dealers, good dealers, average dealers, worse-than-average dealers, and a few terrible dealers. The art they sell ranges, in like fashion, from excellent to awful (depending, of course, on individual tastes and preferences). Most dealers' prices are fair and reasonable, but of course there are some whose prices are ridiculously inflated. Once you learn how to meet, understand, and communicate with dealers, then you will be able to differentiate between those who sell good-quality art at the right prices and those who don't — and those who have the best (and worst) selections for your needs and your budget.[61]

Most galleries are selling what could be described as luxury items on the upper end of the economic scale, and their spaces often reflect this fact in their ambience. Generally, the hotter the artist and the more

prestigious the gallery, the more the dealer can demand from the public. Art, in large part, follows the law of supply and demand. The prices of any artist's work start to rise with the sales of his works to important collectors, favourable critical reviews, cultural and institutional support or shows, and the buzz or publicity surrounding his art. Every artist realizes that the more he is exhibited, especially in major museums and galleries, the more success he will have. As this effect snowballs, the demand for his work rises and the prices go up with it.

How do dealers arrive at pricing for an artist with no public record at auction? Some general factors they consider are the size of the work, the medium, whether or not the style of the work is fashionable, and the popularity of the artist. Beyond those measures, dealers have to use their own judgment by comparing it to other works of art they've owned, seen, and exhibited. There is a balancing act between the artist's desire to get the most he can for his paintings immediately and the dealer's desire to move pricing upwards as the artist's reputation grows.

Determining the pricing for a new artist's work is an art in itself, and the price may or may not be a true reflection of an artwork's economic value. Quite simply, the price is based on the dealer's opinion, and often he is testing the waters. In his memoirs, famed dealer G. Blair Laing said, "During my art dealing career I can remember a number of people who were blessed with the ability to recognize the quality of a picture outside its own context. What I mean is, the capacity to judge quality in isolated examples of an artist's work."[62] If the price the dealer sets is too high, it may inhibit the career of a young artist, and if it's too low, it may cause a perception of lack of quality. Generally, a dealer starts an artist off at the lowest possible price because there is an unwritten rule that price decreases can be disastrous to an artist's career. Most artists who don't sell well will change galleries and start fresh rather than have prices discounted at their current gallery. It is much easier to raise prices than to lower them.

Many dealers find that what the public buys at a show is often not what they consider to be the artist's best work. Therefore, it is almost always true that each piece within a show is priced based on its size and medium and the other less tangible criteria mentioned above rather than on the dealer's opinion of the quality of each piece. Dealers want

buyers and collectors to determine what *they* consider to be the best in each show, rather than imposing their tastes on the public. If you ask a dealer what he considers to be the artist's best work in a particular show, you might be surprised by what he has to say!

With art on the secondary market, there will probably not be a number of similar-sized works to compare, so each piece of artwork is priced based on to its rarity, provenance, history, and quality. Judith Benhamou-Huet comments, rather cynically in my opinion, on the dealers' power in the market:

> The colossal sums of money at stake have transformed these middlemen into purveyors of a variety of services. These new Shivas of the art market — both creators and destroyers, capable of sweeping up the world of art in their "cosmic dance" — will, in turn, sell, buy publicly or secretly, finance, advise, dissuade and promote, but also guarantee, act as the art critic and turn into art historians. They accumulate these often incompatible roles for the sole purpose of pushing prices higher.[63]

In my experience, most dealers, within the context of the fantasy world of the art market, price their artworks based on what is best for the artist and for themselves, while reflecting the quality of the art and its stature within the artistic whole.

Buying Art from a Dealer/Gallery

In the shifting and often illusory world of art, a long-term arrangement with a first-class dealer can have tremendous advantages for you as a collector. The gallery owner will have already done a lot of your homework for you before you even enter the gallery. A gallery's role, as seen through many collectors' eyes, is to perform an initial screening process and sort out legitimate talent from mediocrity. Marques Vickers suggests that we have to take the word *talent* within the context of the art gallery system of doing business and realize that not all gallery owners

have an eye for it. "The term 'talent' is often a gross overstatement, because the judging of art is mostly subjective and the price of the work is determined more by marketing investment than by quality."[64] As stated, regardless of what the dealers have judged as quality, the final arbiter of quality and talent is you.

The vast majority of professional art dealers are experts at what they do. Passion, feeling, and visual impact all play significant roles in their selection process, but there's more. When they see art they like, they research it, evaluate its quality, see what else is available in that category, compare prices, and ultimately determine whether they can remain competitive with other galleries by buying and then selling it. They comparison shop for art that has the most value from business, aesthetic, and quality standpoints.[65]

An art dealer has who has been in the business for many years has built up considerable knowledge of his field. This business of art collecting and buying and selling is in itself a progressive system of education and aesthetic refinement. A substantial output of money and effort is required to cultivate preferences and discern long-term value: there is the cost of a primary education in university; the time and expense of attending seminars and lectures; the cost of books and magazines; the time expended at openings, museums, art fairs, other galleries; and the experience and wisdom that comes from being around any business for years. A good art dealer has all that and more, along with a certain sensibility and instinct that must be cultivated and refined over time. As long-time dealer G. Blair Laing wrote in his memoir, "Probably the next best thing to being an artist is having the opportunity to deal in good art. But you don't learn about art the same way you are taught astronomy, or for that matter, the history of art at a university. The learning process I refer to relates to having an inherent feeling for a piece of art. Having a good eye for a picture is rather like being born with a good ear for music; you either possess it or not, because this sensibility can rarely be instilled in a person."[66]

The kind of expert counsel and advice a dealer can provide does not come without a price. It is up to you to decide if the expense is worthwhile for the kind of art you want to buy or collect. Often you just have no choice in the matter: the art is there, you love and want it, so you buy

it! The late Walter Hopps, who was curator of twentieth-century art at the Menil Collection, recalled what his wife once said about purchasing art: "The price of a really great work of art is always a little more than you want to pay ... so if you're going to get it, you have to pay it."[67] Isn't that the case with most rare and precious items?

How to Be a Savvy Buyer

There are several things to keep in mind when buying art from a gallery. First, try to separate the story from the piece of art. Dealers and their staffs are adept at presenting anecdotes about their artists that both humanize them and stress their unique position in the field. Remember, these stories can be less than objective, as the storytellers are motivated by the possibility of financial gain.[68] I was once considering purchasing a Renoir sketch in an art gallery on Rodeo Drive in Los Angeles. The gallery's two owners spent about an hour describing to me everything that was happening to Renoir at that time in his life. Their enthusiasm was palpable and the stories captivating, but the small, charming, unsigned pencil sketch was US$80,000 — grossly overpriced, in my opinion. Nevertheless, that's what gallery owners and their staff are good at: talking up the art while at the same time distracting you from thinking about the price. So listen as they tell you their anecdotes about the artist but try not to get intoxicated by the romantic stories and let them override your rational judgment. You have to base your decision on the merits of the artwork relative to your desire to own it and whether the gallery is charging a fair market price.

Be aware of the ambiance in the gallery. Naturally, the gallery environment is designed to optimize the aesthetics of any piece of work it is selling, so remember that you are likely viewing the art under optimum conditions, with the correct lighting, flattering background wall colours, and minimalist setting. You have to compare this setting to the one you are planning for the artwork. How will it fit in there? With a painting, it might be good to try it out in its new environment before you fully commit to buying it. Often you can either take the piece home for a trial or rent it for a couple of months; if you decide to buy it, the rental fee often comes off the purchase price.

When you have finally made a decision to purchase, make sure you take full advantage of what the gallery has to offer. Don't be afraid to ask for a discount, especially when you're buying more than one piece of art. I wouldn't have half of my collection today if it weren't for the flexible financing and discounts offered by the galleries! You could start by offering a flat amount at least 25 percent below the asking price and work upward until they agree to pay all the taxes. (If they accept cash or pay the taxes, make sure you get a bill of sale showing that the taxes have been assessed and paid and that all the conditions, authentications, and guarantees are clearly noted.) Alternatively, the finest galleries may also offer money-back guarantees, guarantees of authenticity, full condition reports, updated appraisals, trade-back arrangements, and personal consultations on your private collection. You never know what you can get unless you ask!

Gallery Art as Investment

Buying from dealers for investment purposes is very difficult because you are paying retail and will someday have to sell at wholesale. In most cases, the piece would have to appreciate significantly — often the price would have to more than double — for you to break even. In addition, the commissions and expenses for selling are very high. The chances of a contemporary artist's prices rapidly escalating in the Canadian art market are slim. Most contemporary artists' prices rise gradually over time as their reputation grows. The art market is really very small and controlled by a very few players. For most art, it is definitely a buy and very long hold proposition. We started buying Doris McCarthy's art from her dealer more than twenty years ago and we have seen her prices rise incrementally every year, both on the retail and auction markets. No one can, with absolute certainty, predict what the future will bring. It looks like those paintings will prove to be a sound investment but it has taken a long time for the prices to escalate to a break-even point from the original retail pricing. Of course, I want her art unconditionally for its beauty and artistic merits; its present or future valuation is an entirely separate and independent matter. (Does that not in itself epitomize the dual nature of the art market?)

When you hear about an Andy Warhol print that some astute individual bought from a Toronto gallery in 1969 for $1,100 and sold for over $2 million at a New York auction in 2002, remember that particular example is akin to winning the lottery and not at all typical. Much more often, I have seen very expensive paintings purchased at high-end galleries offered in the aftermarket for a fraction of their original cost. Conversely, I have also seen bidders pay far more at auction for secondary market pieces than they would have paid for a similar work from a dealer with all the backup, advice, and guarantees a gallery can offer.

The difference between art and many other commodities is that fine art is unique and you might come across a particular piece only once in your whole life. So if want it, buy it, and enjoy it for a long time. After all, you usually don't worry about the future value of your couch, do you? No, you buy what you like, what you can afford, and what looks good in your home. The truth is that galleries are the best depositories of the newest and best art being produced today.

How to Pick a Good Dealer

Most cities have neighbourhoods where fine galleries are clustered, and you can learn a lot by looking, visiting, and comparing. Some galleries show only very expensive art while others feature emerging or younger artists, and there are galleries for everything in between. By visiting them and attending their shows and talking with the dealers and their staff you will soon figure out which ones fit your needs. As Aldous Huxley said in his book *The Perennial Philosophy*, "The science of aesthetics is not the same as, nor even a proximate means to, the practice and appreciation of the arts. How can one learn to have an eye for pictures, or to become a good painter? One learns to paint by painting, and one learns to appreciate pictures by going to galleries and looking at them." After all, there are really only two determining factors in choosing a dealer — do you trust the dealer and like his taste in art and do others trust him and widely support his choices in artists? You determine the first yourself by asking questions and listening to the responses, and you determine the second by asking others about a dealer's

reputation and looking for media and cultural recognition to ascertain if he is well respected in the art world. The fancy location of his shop, the amount of expensive advertising he does, or the size of his inventory are all unimportant in comparison with how the dealer treats you as a valued client and how you relate to his art. In the final analysis, the dealer is just the facilitator; the real expert is you. As dealer and collector Charles Saatchi said, "Nobody can give you advice after you've been collecting for a while. If you don't enjoy making your own decisions, you're never going to be much of a collector anyway."

The Art Dealers Association of Canada (ADAC) is a group of commercial galleries across Canada that provides professional, ethical, and financial standards for its members and consumers. Its members are the elite dealers in any Canadian city, and you can ask whether or not a gallery belongs to this association. Members must have been in business for at least five years, so inexperienced dealers and fly-by-night operations will not be listed. You can find a list of members on ADAC's website, www.ad-ac.ca. There are, of course, many outstanding dealers who do not belong to this association but have art and artists that may appeal to you, but dealers who belong to ADAC are, in my opinion, most likely to have art that will increase or hold its value over time.

Now that you understand how galleries operate, how artists and galleries work together, how art is priced, what a dealer can do for you, and how to choose the right dealer, you shouldn't hesitate for a moment when a painting catches your eye from a gallery window. Just buy what you like and enjoy it. In the next chapter, we will explore the other major venue for purchasing fine art: the auction house.

CHAPTER 7

The Smart Guide to Auctions

*"It is only an auctioneer who can equally and
impartially admire all schools of art."*
— Oscar Wilde

Auction Houses: A Brief History

An auction is the process of buying and selling things by offering them
up for bid, taking bids, and then selling them to the highest bidder. In
economic theory, an auction is a method for determining the value of a
commodity that has an undetermined or variable value. The auction
model of exchange, which openly applies the law of supply and demand,
sells artworks as openly and transparently as possible, with the artwork
going to the person willing to pay the most on any given day.

Historians suggest that the first auctions occurred in Babylon in 500
B.C. The Romans, whose word for auction was *octio*, used the auction
process to liquidate their own property. Sales were advertised, bidding
was actively encouraged, and participants speculated and prospected for
deals.[69] During the seventeenth century, auctions came to be held in tav-
erns and coffeehouses to sell art. Such auctions were held daily, and cat-
alogues were printed to announce available items. During the American
Civil War, goods seized by armies were sold at auction by the colonel of
the division. Thus, today's auctioneer in certain parts of the U.S. carries
the unofficial title of "colonel." In Canada, there still exists a copy of an
auction catalogue published in 1823 that was, according to experts, the
first art catalogue published in Canada. Waddington's Auctions began

operations in Toronto in 1850 under the name "C. M. Henderson & Co. – Auctioneers." The oldest fine art gallery in Canada, Roberts Gallery, established in Toronto in 1842, also held fine art auctions in Toronto in the late nineteenth century.

The world's four largest auction houses for fine art are Christie's, Sotheby's, Phillips de Pury & Company, and Bonhams. They were all founded in London, England, before 1800. Sotheby's, established in 1744, was the first, and the others followed soon after. Christie's and Sotheby's are the world leaders in volume and global presence. They both have offices around the world and fight one another tooth and nail over the bragging rights of being the top house in terms of total sales and of offering the most prestigious and expensive paintings. During the 2006 fall art sales in New York, in one week alone, they came just short of $1 billion in total art sales, with Christie's taking credit for the largest auction art sale in history, with US$491 million changing hands.

In Canada, the big three for fine art are Heffel, Joyner Waddington's, and Sotheby's/Ritchies. Others include Ritchies Auctions, Walker's Auctions, Levis Fine Art, Hodgins Art Auctions, Empire Auctions, Maynards Auctions, Dominion Auctions, and Westbridge Fine Art. The finest and most sought after artworks in the country are offered in their premium fine art sales, held in the late spring and fall. Heffel switches between Vancouver and Toronto each season, and Sotheby's, in association with Ritchies and Joyner Waddington's, holds semi-annual sales in Toronto. Levis and Hodgins conduct their sales in Calgary, Walker's in Ottawa, Maynards and Westbridge in Vancouver, and Dominion in Winnipeg. According to the 2006 auctions results, Heffel has a 42 percent market share, Sotheby's in association with Ritchies has 23 percent, Joyner Waddington's has 13 percent, and all the rest combined make up 22 percent.

The total of the annual sales for these events is now close to $50 million, with numerous other sales from other auction houses and online sales during the year probably doubling that total. It is estimated that in Canada auctions probably account for about 20 percent of total fine art sales, but, as is happening in the U.S., the Canadian auction industry is fast becoming the country's distribution outlet of choice.[70] There are somewhere in excess of 6,500 Canadian artists whose works have sold at

auction over the past twenty-five years, with combined sales in the region of $260 to $300 million. With this in mind, it is interesting to note that approximately 88 percent of all works sold at auction sell for less than $5,000, and close to 75 percent sell for less than $2,000. Even more interesting is the fact that less than 1 percent of Canadian artists control in excess of 70 percent of the annual market turnover at auction.[71]

Most fine art auctions are held in the model commonly used by English auction houses like Sotheby's, Christie's, and Phillips. Participants bid openly against one another, with each bid being higher than the previous bid. The auction ends when no participant is willing to bid further, or when a predetermined reserve price is reached, at which point the highest bidder receives the prize. The seller usually sets this reserve price in collaboration with the auction house, and if that price is not met or exceeded, the item remains unsold. The auctions, although held in public, are designed so that buyers have the option of remaining anonymous through sealed bids known only to the auctioneers, called absentee bids, or through telephone bidding.

There are other types of auctions where fine art is sold, but they are not regularly scheduled events. These include charity auctions, silent auctions, estate auctions, and fundraisers.

How Auction Houses Operate

Some auction houses specialize in fine art sales, but the majority schedule art sales as part of their ongoing annual auction schedule. Their auctions can include everything from general estate auctions to high-end auctions that feature catalogues, estimates, and previews. They also have auctions featuring specific genres of art such as international, Canadian, or Inuit. The quality and price of the art usually move upward with the exclusivity of the sale.

Auction houses conduct formal appraisal services for a fee but also provide a general range of estimates of what a particular artwork might fetch at auction. If the work is of significant interest and value, they will travel far and wide to secure the piece for their next appropriate sale. All auction houses are looking for quality works by important artists that

have not been offered before, but in reality they often have to settle for what is available in the marketplace at the time of the sale.

As the auction houses acquire artworks, they decide which sale each piece is destined for, with the best pieces going to their premier shows and the others assigned to the weekly, monthly, or quarterly auctions. With each fine art piece, the auction house and the seller negotiate a reserve, which is a confidential minimum price below which the auctioneer agrees not to sell the piece. If the reserve is met, then the seller receives that amount less the auction house's commission. Usually there is a sliding scale, published by the auction house, that outlines the seller's commissions. The lower the selling price, the higher the commission to the auction house. Every now and then an artwork will be sold without a reserve, for any number of reasons, including estate or charity consignment, in which the seller will accept whatever price it realizes.

Most reserves are set anywhere from 20 percent below the low end of the estimate right up to the low end itself. Once the recommended high and low estimates have been proposed, then reserves are set in place. Estimates are important marketing tools that can make or break a sale. Richard Polsky, an art dealer and author based in San Francisco, says, "The estimates are a tease. Auction houses are trying to pick a number that attracts bidding but shows respect for the work of art."[72] Estimates are determined by a very inexact science, but they do offer guidelines that indicate what the auction house experts and appraisers think any particular painting is worth. If the estimates are too high, they may dissuade some potential buyers from bidding. If the estimates are too low, they may discredit the value of the work in some people's eyes. The estimates become set points and therefore have a tremendous psychological effect on potential buyers.

Auction houses in general do not like to overestimate the value of any artwork, as a lower starting point will usually get the bidding going, and in the end the piece will attract only what someone is willing to pay, regardless of the estimate. It is very much like the real estate market. Many owners want to start out with a high list price, but the house can become stale very quickly if it doesn't sell. Most agents like to price real estate very near or slightly above the market value to attract multiple bids and end up with a final sale price that is higher than the original list

price. In actuality, according to Stephen Ranger, President of Ritchies Auctions, over 70 percent of all paintings sell within the estimates established by the auction house experts. Of course, there are also many paintings that sell for an amount far beyond the estimates because on that day at least two people wanted them and were willing to pay whatever was necessary to get them. Many paintings also fail to attract bids that meet the hidden reserve price and don't sell at all. These paintings are "bought in" or "passed" at auction.

There is a growing trend among auction houses to offer guarantees to the consignor, either on a whole collection or on one very valuable piece. The guarantee is an amount that the auction house will pay to the consignor regardless of the outcome of the auction. Some guarantees establish a pre-set price for the artwork, and if the result exceeds that price, the consignor receives all of the additional amount, a portion of it (usually half), or none of it.

I have read about guarantees made on much sought after collections that have cost auction houses millions and others that have made them millions. John Nash, a partner in the New York dealership Mitchell-Innes & Nash, recalls the flourishing of the guarantee in the early seventies: "In those days the guarantee wasn't used as a competitive business-getting tool. My understanding of it today is that the potential seller's first question to the auction house is 'How much will you guarantee?' Sellers are playing one house against the other, with the result that the auction galleries have to give very high guarantees in order to get the property. They have an auction before the auction."[73] Many people inside the art business find the guarantee somewhat odious in that it takes away from the free and open market approach that auctions are supposed to offer. The auction house has, in effect, become the owner of the goods before the sale has started, and there is a perceived conflict of interest in that.

With or without any guarantees in place, the next step for the auction house is to prepare the catalogue. All the artwork to be offered is photographed and arranged in an order designed not only to keep the pace of the sale exciting but also to offer the big-ticket items at strategic points throughout the sale. The catalogers either seek outside help or write informational articles themselves to add details to the description

of the artwork beyond the usual title, artist, size, medium, provenance, and literature. These may include information about how it was discovered, its place in the artist's history, how it compares to other works of the artist, and, of course, famous collections it has been in and how rare and unique it is. All of this is designed primarily to add context and interest to the artwork with the purpose of attracting more and higher bids. The finished catalogue is then made available online and also printed and mailed to the auction house's regular clients and sold to anyone else who wants to purchase it before or after the sale.

For months before the sale auction houses use their extensive network of potential art buyers to promote their upcoming sale. Their promotion efforts may include phoning or emailing any collectors who have previously shown an interest in a particular artist or period or style. Many take their art on the road, holding mini previews of the best works in major cities across Canada. Finally, they schedule full previews of all the works for a two- or three-day period before the start of the auction. Inevitably, previews have the look of a rummage sale, with all these great artworks stacked upon each other and squeezed into every nook and cranny of the showrooms. In the end, it all just looks like so much merchandise, but it certainly attracts the crowds who want to preview the auction or just want to see that much fine art offered for sale, in one place, at one time.

Until a set time in advance of the sale, usually twenty-four to forty-eight hours, bidders may pre-register by filling out the paperwork, giving credit information, and signing the form that says they intend to pay for what they buy. This saves on the lineups and inconvenience of having to register on the day of the sale. The auction house also accepts bids from people who will not be present at the sale, as mentioned, called absentee bids, and lines up telephone personnel to call those who wish to place their bids over the phone while the auction is in progress. Telephone bidders are called shortly before the item they are interested in comes up for auction and are not obligated to bid or stay in the bidding any longer than they desire. Absentee bids may include one price only, permission to go as high as a certain price, or no-limit, bid-until-you-get-it instructions. Most fine art auction houses will not accept "buy" bids, instead requiring that all bids must have a maximum value to safeguard the bidder.

The sale itself is conducted by numerical order from the catalogue. Some items may be withdrawn from the sale and others may be added later by means of an addendum to the catalogue. These additions are usually given a number with a letter beside it, for example 26A. Different auctioneers will conduct their sales in different manners, just as an orchestra leader will conduct a band in a particular style. Each one is trying to gauge the mood of the crowd with each offering and keep the competitive energies flowing by gently coaxing bidders ever higher. The last thing they want to do is dampen the mood of the crowd. Their job is to wring every last bid out of the audience and the phone bidders, while at the same time keeping the flow and the timing of the auction on track. Auctioneers can dramatically affect the overall results of an auction with their keen sense of timing and awareness of the mood in the showroom at all times.

Auctioneers will announce an opening bid either somewhat or way below the reserve to get the bidding started. If there is an absentee bid offering a firm starting amount that is higher than the lowest amount in his book he will open the bidding there. Once he has an opening bid, an auction is underway. If the opening bid is below the reserve, the auctioneer usually refers to his book and continues to increase the bids until that minimum is reached. The bidding is raised in increments open to the discretion of the auctioneer until there are no other bids. As a rough rule of thumb, bidding often increases in increments of 10 percent of the last bid. Bids below $1,000 may go up $25 to $50 a bid; over $1,000, $100 a bid; over $2,500, $250 a bid; and so on. Auction houses generally prefer to keep to these standard increments because they do not want to appear to be treating some clients differently from others, but there are a lot of variations between auctioneers and at different points in the sale.[74] During the sale of Picasso's *Boy with a Pipe*, Tobias Meyer, the chief auctioneer for Sotheby's, pushed the price up another $20 million to a record $104 million just by sensing that something was going wrong with the pace of one of his bidders. He delayed and stalled until the cellphone connection between the bidder and the buyer was restored and the war over the most expensive painting ever sold at auction could reach its historic conclusion.

As the bidding on each item slows down, the auctioneer will offer some sort of warning that he intends to sell it at that last bid amount if

there are no further bids. He then brings down the hammer and the item is sold to the highest bidder. The amount of the winning bid is called the "hammer price." The final purchase price is the hammer price plus the buyer's premium, which can add on an additional 20 percent. Taxes are paid on the combination of the hammer price and buyer's premium. The seller receives the hammer price less the seller's commission.

Soon after the sale the auction house will publish the prices realized for each item and the total of all the sales, along with announcements of any new records that were established during the sale. These figures give the house bragging rights for the next sale and establish market leaders in both the kinds of art sold and the prices achieved.

What You Need to Know about Buying at Auction

Auctions can be very expensive training grounds for the inexperienced buyer, but at the same time they provide opportunities for incredible bargains. My strong advice for those not conditioned to the auction experience is to observe as many as possible until you feel comfortable with the process before jumping in. They can be intimidating and exhilarating experiences, and the last thing you want to do is get caught up in the emotions of the moment and bid an amount far beyond what you wanted to pay or purchase something that you regret the next day. The emotional frenzy that bidders sometimes experience at auctions is referred to as "auction fever."

First of all, you should know what you are looking for, why you want it, and approximately how much you are willing to pay for it. Once this is established you can then look through the auction houses' catalogues to determine which pictures fit into your criteria, more or less. You can do your own research to see if the estimates seem realistic. The most useful auction records for your purposes are those that describe works of art by that artist that are the most similar in size, subject matter, medium, date executed, and other particulars to the one you are researching. Auction prices of contemporary artists should generally be at least 50 percent lower than gallery prices. The works of

art that have the highest estimates are usually the ones that collectors want the most, and the works with the lowest estimates are usually the least desirable to collectors. There is a rationale behind the estimates for every artwork, whether they are very high or very low, and it is up to you to unearth the reasoning. It may be that the estimate is too high because of unrealistic demands on the part of the consignor or that the guarantee offered by the auction house was too generous, or it could be wishful thinking on the part of some inexperienced appraiser who has not done her homework.

Be sure that you understand the terms used to describe the artwork in the catalogue. I have explained many of the art terms you will come across in Chapter 2: Demystifying Art Terminology, but the following terms are mostly unique to auctions and must be noted. When the catalogue adds anything to an artist's name such as "manner of," "studio of," "circle of," and so on, beware, because they are saying that it is not by that artist. "Attributed to" is also dangerous because it means they are only offering an opinion on who might have been the artist. You might also pay attention to the signature descriptions: "signed" is good, "bears signature" is not. In most cases, an unsigned work is less valuable than a signed one, but with very well known artists it is less of an issue. Still, for resale and posterity, a legible signature is a valuable asset to have in a painting.

In the end, the responsibility to know what you are buying rests with you. Once you're sure you understand what is being offered, remember that the estimates listed in the catalogue are only someone's opinion, and the money you end up paying will be yours! You need to attend the preview, if at all possible, to view the art you are intending to bid on and check out its condition for yourself. Even beyond the condition, I have many times been surprised at how different a painting or sculpture looks when I see it in person. Often the picture in the catalogue or online is not a true representation of the colours and mood of a painting. Except when I really know the painting or have seen it before, I make it a practice never to bid on a painting without seeing it first. At the preview, ask the auction staff in charge of art to tell you everything they know about the art you are interested in bidding on. Ask about its condition and, if necessary, get permission to look at the back of the painting to see if there are any clues or warnings signs. The

staff will even take the picture to a darkened back room and hold a black light over it so you can see any signs of repairs or overpainting.

After doing your research and attending the preview, decide what your maximum bid will be for each item you're interested in and plan to stay within one or two bids of that amount, depending on the increments and the mood of the other bidders in the room that night. You can't be too rigid, because sometimes you get a feeling that just one more bid might get you that piece you really want. You will discover the bidding technique that works best for you over time. With auctions, the combination of research and experience makes perfect.

Before the sale you have to decide whether to attend in person, put in an absentee bid, or bid by telephone. I always advise my clients to be there in person if at all possible, because only when you are in the room can you sense the emotions and energy of the moment. If you cannot be there in person, telephone bidding is an excellent option, as it forces you to focus on only the paintings you are interested in and eliminates the distraction of the others. It does, however, have two distinct disadvantages. First, the auctioneer customarily takes "order bids" (those made in advance of the sale) and bids from the room before he takes telephone bids. Additionally, the phone bidder may have difficulty sensing the general mood in the salesroom and the enthusiasm (or lack thereof) for a particular lot. As a result you might either lose out on what you wanted or bid on a lot for which there was no other interest and which might otherwise have been purchased more cheaply in an aftersale transaction.[75] Alternatively, an absentee bid can be fine, if you want the picture only at a certain price and no more. Never leave an open-ended bid unless money is of no consequence to you at all; if there is a great deal of interest in the item, the sky can become the limit and you can end up paying more than you ever imagined. It can be a very dangerous and expensive bidding option.

"In every sale there are always 'holes,' moments of collective absent-mindedness or delayed reactions that give you a sporting chance,"[76] art market reporter Souren Melikian advises. Watch for these occasions, and if they happen during the bidding for a painting you want, be ready to pounce. This is where you can pick up a real bargain at an auction.

There are also strategies for where to sit, when to raise a paddle, and

how aggressively to bid. It's really all a matter of preference. Some prefer to sit at the back of the room so no one can see them but they can observe the action on the floor. Others prefer to wait until all the fury and the bidding is almost over before they jump in. Some, like my wife, for example, prefer to just raise a hand and keep it up until they get what they want. This strategy can show strength and determination and possibly put off bidders who are not all that serious. You can usually tell bidders are weakening when they take a long time to respond to the pleadings of the auctioneer for "one more bid." My personal pet peeve is when you really want a painting and there is no way on earth you are not going to get it, and some bidder goes for one last gasp and makes you go up two bids to get it. Those half-hearted entries have cost me thousands of dollars!

In any case, it is important not to get swept up in the excitement and go beyond what you want to pay. There will always be other opportunities. If the price goes too much beyond your high-end range, just let it go and be ready for the next on your list. As someone once said, "You never know when someone will not give up and for some reason will not let go." Let them have it!

You should be aware that auctioneers are allowed to announce fake bids, sometimes known in the trade as "chandelier bids" because no one is actually bidding but he is pointing at the ceiling or chandelier. At first, I was very confused by these bids because it sure seemed to me that there were multiple bids, but eventually the item would go unsold. By law, auctioneers can do this only until the reserve is met; beyond that they would be guilty of "shilling," which is the practice of announcing fake bids over the reserve in an attempt to induce bidders to purchase at excessive prices. Another practice called "chill bidding," or "pool bidding," occurs when bidders get together and agree not to compete against each other on a lot in the salesroom, thereby permitting one member of the ring to acquire a work at a lower price. Afterward they hold a private "knockout" auction, where they bid amongst themselves for the work. This can happen at lower priced and sparsely attended auctions, but rarely, if ever, at major fine art auctions.

If the high-pressure, fast-paced environment of an auction is not your cup of tea, then you can hire an art dealer or consultant that you

know, trust, and can confide in to inspect, research, and bid on the art for you. There is a fee for this service, usually a percentage of the final cost of the artwork or an hourly rate, but it can often save you money in the long run. Not only is the consultant's advice before the sale very valuable, but there is no chance she will go beyond your highest dollar bid as she is not emotionally involved with the purchase.

Pay particular attention to "passed items" or "buy-ins," as these can be purchased after the sale. Auction houses can and do sell many artworks at or near their reserve price (they cannot reveal the exact reserve because it is a private matter between the consignor and the auction house). However, the auction house will call consignors to see if they will accept a lower price than the reserve and thereby complete the sale then and there. They will often accept the deal rather than have to take the picture back and start the process over again.

You also need to be fully conversant with the terms and conditions of the sale. Auction houses almost always publish these in the front or back of their catalogues. The most important disclaimer is their responsibility with regards to their accuracy of the information they publish. Although good houses will stand behind what they sell, what they are offering is, for the most part, an informed opinion. Once that hammer has gone down, the painting is yours.

The other important point is to be aware at what levels and percentages the buyer's premiums are set. This amount, which is added to the hammer price, ranges from a low of 10 percent to a more usual 15 or 20 percent. In addition to these charges will be taxes, possible shipping, and your own increased insurance and framing and/or restoration costs.

Auction House Legalities

In light of all the above, and since a majority of sales on the secondary market take place through auction houses, I thought it would be helpful to review some of the legalities involved. One of the most well known recent lawsuits brought against an auction house involved Taylor Thomson, daughter of the late Ken Thomson, who claimed that she was misled in her purchase of two seventeenth-century urns for

£1.9 million in 1994 from Christie's auction house in London. The case has everything to do with auction houses' responsibilities for statements and claims made in person and in the sales catalogues to both prospective bidders and the winner of the piece. In 1998, the authenticity of these urns was brought into question; it was suspected that they might be nineteenth-century reproductions, worth only £20,000 to £30,000. Subsequent tests appeared to confirm the suspicions, prompting Thomson to take the auction house to court. The judge acknowledged that Christie's was not "obliged to give the full and detailed advice that might have been expected of an independent art expert" but that the "circumstances required that Ms. Thomson be told the risk she ran in paying a large sum for the urns." Thomson was awarded damages, interest, and costs. However, the decision was appealed and subsequently overturned by a higher court. This case was based on a particular set of unique circumstances and should not be interpreted as a legal standard, especially in Canada, by which all auction houses and bidders will be held accountable. You should be aware that unless there has been an outright attempt to defraud bidders, the auction house is not responsible for any item after it has been sold.

In fact, here are some "conditions of sale" from a well-known Canadian auction house:

> All lots are sold "AS IS". Any description issued by the auctioneer of an article to be sold is subject to variation to be posted or announced verbally in the auction room prior to the time of sale. While the auctioneer has endeavored not to mislead in the description issued, and the utmost care is taken to ensure the correct cataloguing of each item, such descriptions are purely statements of opinion and are not intended to constitute a representation to the prospective purchasers and no warranty of the correctness of such description is made. ... Some lots are of an age and/or nature which preclude their being in pristine condition and some catalogue descriptions make reference to damage and/or restoration. The lack of such a reference does

not imply that a lot is free from defects nor does any reference to certain defects imply the absence of others. It is the responsibility of prospective purchasers to inspect or have inspected each lot upon which they wish to bid, relying upon their own advisers, and to bid accordingly. ... The auctioneer acts solely as agent for the consignor and makes no representation as to any attribute of, title to, or restriction affecting the articles consigned for sale.

If you make a bid at auction and that bid is accepted and the hammer goes down, you have entered into a contract with the auction house to purchase those goods. The actual title is transferred when you pay for the goods. Most bidders do not know this, but you do have the right to withdraw your bid — but you must make it very clear to the auctioneer that you wish to do so *before* he brings down the hammer and announces that the item is sold. The auction house will set time limits for you to pay for and pick up your artwork. If you fail to pay for your purchase in a timely way, then interest and storage charges may start to accrue on your purchase.

What You Need to Know about Selling at Auction

You have the choice of selling your artwork to a dealer, privately to an individual, or at auction. While different factors come into play with each of the various choices, there are conditions and strategies that you should know about when planning to sell an artwork at auction. An auction will give your painting very wide exposure to a large number of art purchasers and collectors. The first step in selling a painting at auction is to decide which auction house can best market and promote it to help it reach its maximum selling price. While no one can predict exactly what will happen at an auction sale, you should consider the market and history of the various auction houses. Does the painting have only regional appeal? If so, you might want to place it in a local auction where collectors interested in such works are likely to be. How have similar examples by this artist

fared with this auction house? Auction houses known for a certain artist or genre will naturally attract interested collectors. What kind of advertising and previews are they planning? Do they publish a catalogue? Is their catalogue fully or partially in colour? How many copies do they distribute? These are all indications of the strength of their marketing efforts that will more fully publicize your painting. You might also take the painting you want to sell into a few different places, or email pictures and a description, to see how interested they are and compare their estimates.

Once you have decided on where to place the painting, you have to negotiate a reserve, which is the most important part of the process. The reserve must be lower or equal to the low estimate; it cannot be higher. Choosing the right estimate for your painting will improve your chances of achieving a high price at auction. If your estimate is too high, then you risk discouraging the interest of knowledgeable bidders. You should agree to price your painting on the low side, but not so low that you might arouse suspicions that something is wrong with it. Remember, it takes only two interested parties to drive up the price of your painting, and, as with real estate, the highest prices are realized when there is a bidding war. If your painting passes at auction — if it doesn't sell — it's said to be "burned." A painting once burned at auction is hard to sell again, at least right away. You will probably have to take it off the market for a number of years until it's considered fresh again.[77] You also have to pay a seller's commission, which comes off the hammer price, if it sells, and other additional fees, even if it doesn't sell, such as photography and catalogue charges and possibly insurance and storage charges.

What You Need to Know about Pricing at Auctions

Leslie Waddington, a prominent dealer and director of Waddington Galleries in London, says, "There are actually two art markets. One is the everyday market, which takes place in galleries around the world. The other takes place in auction rooms." Waddington calls it the "ego market." "People will pay far more there than to a dealer," he says. "They're often just showing off."[78]

Traditionally, and until quite recently, galleries and auction houses coexisted within mutually understood boundaries. Art galleries were primary sales outlets for artists consigning their new works, and high-end auction houses cultivated a secondary market representing owner's consignment and reselling inventory. Lately, however, auction houses have taken a more active role, blurring the lines and in many people's minds taking over the role of the dealer.[79] Jane Kallir, co-director of Galerie St. Etienne in New York, says:

> The problem with the auction houses is that they attempted to transform themselves from essentially wholesale operations into retail operations. I don't think they can ever be 100 percent retail. When you look at sales results, you see that things can sell anywhere from below wholesale to above retail. And at the same time, there is a perception on the part of the collecting public that the auctions make the market, that whatever a work brings at auction is the true price. But the reality is that this auction price could be way low or way high. As dealers, we always have to explain this to people, we have to figure out where the market truly is, make that market and preserve it.[80]

Faced with a diminishing supply of the highest quality consignment art and a growing number of individuals pursuing it, many auction houses are becoming more aggressive in sourcing inventory, frequently at the expense of art dealers. Certain auction houses began the process by acquiring estate art directly from the sources instead of merely being the conduit between buyer and seller. For premium and high-profile works, it is not unusual for an auction house to contact potential bidders directly and enable them to see the works as well as keep them on loan in their homes or residences.[81] Just recently, some auction houses have purchased shares in prominent dealers' businesses and have taken on artists and given shows at their showrooms, acting exactly as dealers do. They have also taken booths for the first time at major art fairs, until now the bastion of the dealers alone. Former *Art & Auction* magazine publisher Bruce Wolmer summarizes the growing conflict between the two venues:

Historically, people collected mostly because they were passionate about art. ... When the auction houses encouraged collectors to buy at auction, there was a shift in emphasis. Prices began to escalate and collectors began to see that they could wear culture on one lapel and investment value on the other. That's when I think the collector became conflated with the consumer. There are those who continue to collect seriously, passionately, intellectually, but the overall picture has changed as the art market has emerged as financially viable. What is the impact of this on dealers?[82]

The marketplace is definitely in a state of transition, and how it will evolve remains to be seen.

In addition, because of the openness of and the media attention given to auction price results, many people consider auction prices to be the only pricing in art — the one that establishes true pricing. As dealer Mary-Anne Martin of Martin Fine Art in New York observes, "The problem is that the only constantly registered prices or reported prices are auction prices, but how many times is the price itself a very strange, manipulated thing?" Kallir similarly comments on the views most dealers share about auctions:

The truth is that prices are all over the map. As the auction houses become more questionable as players, there's an opportunity for dealers to come in and do what in fact we always do: establish the correct market. Maybe for the first time, the public is going to be in a position to say, Hey, you know, there's something to this. The gallery tries to be fair to both buyer and seller. It is determining a correct price. At auction, it's a gamble, high or low. You can have three lunatics who show up and bid something way, way up, or those same lunatics could get stuck in a blizzard in Minneapolis.[83]

Be advised, however, that dealers naturally have a strong bias against auction houses and are always trying to convince us of the advantages of buying from them and not from auctions.

In my observations and research, I have found that auction prices can be exorbitant for high-end paintings since competing interested buyers usually include museums, corporations, wealthy collectors, and financial speculators. However, it is possible to find excellent bargains for works that are not as well known. Many times at auction I have seen bidders pay huge premiums for paintings that they could have purchased from a reputable dealer almost right across the street with all the attendant guarantees for much less money. As one observer put it, they paid "a first-class price for a second-class picture."[84] After every sale you read the glorious announcements of what everyone paid for their paintings. The auction houses themselves make no judgment about value or the sanity of the final price; they simply announce it as a record price and imply that it is the true value of that artwork, because that is the price it realized in an open market on that day. Judith Benhamou-Huet summarizes auction house logic:

> The major auction houses take a twofold approach to their key customers. They arouse the desire to possess a painting or sculpture by transforming it into a fantasy object, while at the same time, they make would-be buyers compete with each other, pushing prices as high as possible. This diabolically tempting sales strategy leads to a paradox that is unique to this market. Instead of maintaining that the new owner of a work got a good deal, communications about the artwork in question emphasize the fact that the buyer was ready to go through the roof in order to obtain his heart's desire. This logic is retroactive. If such an excessive price was paid for this lot, then there must have been a good reason. And that can only be the quality of the work. The work, it is assumed, is unique and irreplaceable, and therefore, priceless.[85]

No matter how insane the price and how out of line it might be to the rest of the market, auction house logic says the buyer attained his prize because he paid the most for it, so it must be worth that amount.

There can be no doubt that on the lower end of the secondary and contemporary markets auction houses act as clearing houses for unwanted or unclaimed art. Galleries often use auction houses as inventory dumping grounds and secondary sales outlets for slow-selling works, usually to alleviate cash flow problems. If you are after art for your home as decoration or would like a name brand or listed artist's lesser works, then auctions can be incredibly inexpensive. This is especially true of the minor art sales or auctions in which art is just part of the total items for sale. Often, good paintings — even paintings that were originally very expensive on the primary market — are sold for less than the value of the frame. When it comes to the best and the most sought after artworks, however, buying at auction can be quite expensive compared to buying from a dealer.

In the sometimes fierce and psychological battleground of auction proceedings, swollen egos and frenzied bidding often vault prices of minor works to unprecedented heights. Damaged works that have proved difficult to sell under close gallery scrutiny often find a receptive marketplace under the gavel.[86] In truth, the auction marketplace is more of a speculative exchange of assets, like the stock market, and is not a measure of an artist's stature as a talent. Few artists ascend to such a niche market that their works can be resold on consignment. The minority whose work is sold on the secondary market will rarely gain much from its appreciation since they are no longer in possession of their own work.[87] When a painting by E.J. Hughes sold at auction for more than nine hundred thousand dollars in 2004, his voice was piped in live from his home in B.C. He said that he wished he could have sold that painting for that much money when he first painted it, because it was then that he could have used the money.

At least when a dealer buys at auction, anyone can check the auction records to see what he paid and thereby determine if his markup seems reasonable, thanks largely to databases available on the Internet. But when a dealer buys privately, the value of the painting or piece of sculpture is whatever he says it is, and how much he paid for the item remains

a trade secret.[88] Also, with the rise in commissions, there are increased opportunities for dealers to compete in obtaining works for sale. Dealers point to the fact that the auction houses have had to raise their commission rates and especially their buyer's premiums.

Since an artwork sells for the hammer price plus the buyer's premium, that total becomes the actual selling price of the artwork. The seller receives the amount the buyer actually paid less both the buyer's premium and the seller's commission. Therefore, the seller's real commission on the sale is the total of the buyer's premium and the seller's commission as a percentage of the final selling price. For example, if a painting's hammer price is $10,000 and the buyer pays a 20 percent buyer's premium, that makes the final sale price $12,000. The seller receives $10,000 less a 10 percent seller's commission, which leaves him with $9,000. Since the buyer paid $12,000 and the seller received $9,000, in effect the seller paid $3,000 to have his painting sold by the auction house — or 25 percent of the final price. This is the real price you pay for consigning an artwork to auction.

The bottom line, dealers say, is that it can cost a great deal of money to sell at auction. Not only that, but the figures show that there's about a one in three chance that a work won't sell and will be burned. Dealers can say that they're able to sell a work less expensively than auction houses and without any risk that the work will be burned and shown forever in public records as a buy-in.[89] Most dealers will pay you immediately for your picture and some may want you to leave it on consignment, telling you that you will be paid when and if it sells. I know people who have been burned by this, so if you decide to sell to a dealer, arrange to receive payment on the spot.

So, you can choose between the big guns in the art market, the galleries and the auction houses, with all their advantages and disadvantages, or you can go with one of the less traditional venues for buying and selling art. The next chapter will discuss these alternative sources in detail.

CHAPTER 8

Alternative Sources for Fine Art

*"The greatest threat in my view to the existing gallery
sales status quo is that in the next generation, the
marketplace will be populated by consumers weaned
on the Internet, comfortable with online purchases,
and time stressed enough to want to avoid the
gallery experience."*[90]
— artist and author Marques Vickers

Internet auctions and online art sales have transformed the way fine art buyers and sellers do business, allowing them to access previously unreached audiences through technology. The online market, for our purposes, is divided into four sectors: eBay and other auction sites, auction houses' online auctions, galleries' and dealers' websites, and artists' own websites. Other sources for fine art include private art dealers, art consultants, appraisers, and curators.

The Internet

eBay and Other Online Auction Sites

In an online auction, participants bid for products and services over the Internet. This is made possible through auction software that controls the bidding process. The largest and best-known online auction site is eBay, and like most auction companies, eBay does not actually sell goods

that it owns, but merely facilitates the exchange between sellers and buyers. eBay acts as a worldwide marketplace for individuals and businesses to auction off goods and services. Most online auctions, and most on eBay, are English auctions, in which the price starts low and is raised by successive bidders. You may also encounter Dutch auctions, in which multiple identical items are offered for sale and many bidders may win, with winning bids determined by the total value of the price bid, multiplied by the number of items bid on. (See eBay's help section for more information.) Many auctions also have an option to buy immediately at a higher price, such as eBay's "Buy It Now" feature.

As the selection and quality of artwork for sale on the Internet grow, and with increased buyer security and confidence, this market should experience rapid expansion. But because you are buying online from unknown sellers, there are some important strategies you need to know and warnings you must heed.

Make sure the seller you are considering buying from has received a very high level of positive feedback; read through the feedback comments left by previous buyers and beware if many seem dissatisfied. The best sellers will have 100 percent positive feedback because they go to great lengths to please their customers. Reputable sellers will also answer your inquiries fully and promptly.

Most importantly, I would not recommend buying expensive fine art online from private individuals unless you can be certain that if you are not satisfied with your purchase you will have a convenient and safe way of getting a full refund. This caveat applies very strongly to all expensive works on paper, as there is so much potential for misrepresentation. After satisfying yourself that the art you are bidding on is authentic, ask about the packing and shipping methods the seller offers; they should be similar to the methods and costs used by galleries and dealers. Make sure you have adequate time to fully inspect any art that you purchase and an agreement to have the purchase authenticated and approved by a neutral third party. This may take time to accomplish, so you probably need at least thirty days from the time you receive the item to finalize the sale.

The key to winning an online auction is to bid the highest amount of money that you're willing to pay for an item, bid that amount as close to the end of the auction as you possibly can, and keep your identity

secure. The strategy of bidding high and bidding late is known in online auction parlance as "sniping," although it is a perfectly acceptable and often successful strategy. Do beware of "bid shielding," in which two bidders collude to discourage others from bidding on a lot. The high bidder typically outbids his partner, the underbidder, and then withdraws his bid at the last moment, allowing his partner to win the lot at the lower price. If you lose an auction in a case that looks like bid shielding, contact eBay officials; it may have been legitimate, but if eBay can prove fraud they will take action against the perpetrators.

In summary, be careful about buying fine art online unless you are sure that what you are getting is authentic and the seller offers a money-back guarantee if it is not. Art dealer Mary-Anne Martin offers these words of caution: "Anyone can look things up on the Internet. But they can't see that this picture was in terrible condition, that it was a fake, that the measurements were wrong in the catalogue. It's a tool, but you still need a specialist to analyze the prices and to tell you what the picture is worth."[91]

The Internet is not presently the best channel through which to purchase fine art and is still underdeveloped as a secure buying outlet. It will likely be years yet before it becomes the primary market for fine artwork.

Auction Houses' Online Auctions

In the Canadian market, online fine art auctions are growing with each passing year. Heffel Fine Art Auction House has taken the lead, with the other major auction houses slowly catching up, in this expanding marketplace for fine art. The Internet enables high-end auction houses to expand their market to a worldwide audience and reach buyers in the comfort of their homes. For example, during the first week of every month, Heffel.com Online Auctions posts a themed selection of new art on its website. One month it may be Canadian art, the next European and American, the next Inuit, and so on. Each piece is shown as a colour thumbnail that may be enlarged to almost a full page to allow you to go over the painting in detail. Heffel also includes a condition report that lists any problems that are noticeable under normal viewing conditions. Each piece is given a minimum opening bid and required bid increments; the

bidding history is shown as the sale progresses. The items are open for bidding until the last Saturday of the month, when the action really gets exciting. Bidders either put in a single bid or, like on eBay, a maximum "auto bid" that automatically rises in increments from the opening bid as other bids are made. The auction is not over until no one has bid on any item for three minutes, a process that can take hours and can be quite nerve-wracking, just like a live auction.

If you want to see the artwork in person before you bid online, you can visit the gallery. Of course, the great advantage of online auctions is that you don't have to travel to be present at the auction itself, but there is risk involved when you don't preview the art in person before bidding. As discussed in the previous chapter, the most important part of the auction-buying process is attending the preview and seeing the art in person before you bid. If you are bidding on expensive items without seeing them, you should be positive that you know what you're getting. The only artworks I have bought online have been paintings that I know or have seen in person, and I have never been disappointed.

The benefit of buying from an auction house rather than a private online seller is that you'll have the backing of the auction house and its well-established reputation. Just as in live auctions, however, unless there has been some blatant misrepresentation, you will have to pay for the item you won. As technology improves we can expect auction houses to continue to eliminate any shortfalls and security issues that may still exist in online auctions. Check out two Canadian online auctions at www.heffel.com and www.levisauctions.com.

GALLERIES' AND DEALERS' WEBSITES

Almost all reputable galleries use their websites to promote upcoming events, and most allow you to view some or all of their art inventory. This is a highly recommended way of seeing art for the first time, without any of the intimidating factors of the gallery setting. There are no sales people, no pressure, and you can stay and look as long as you like without feeling obligated to buy anything. The only drawback is that most sites don't usually post the prices for anyone, including their competitors, to see. That means you have to call or email for the price. If

you're seriously interested, you should also arrange a time to see the work in person if at all possible.

If the gallery is far away from you, they may be willing to ship the piece to you and let you approve it before completing the purchase; they may also offer payment options and a full money-back guarantee. If you decide not to purchase the piece, you will have to return the art in the condition in which you received it before the approval period expires, just the same as if you were buying in person. There may be additional shipping and insurance costs involved, but as long as you are aware of them up front and they are in line with the value of the painting, that can be a small premium to pay for the convenience. There are thousands of virtual galleries on the Internet, cultivating unique followings and client bases far removed from the traditional institutionalized art-buying audience. These websites are training the incoming generation of art buyers to shop competitively, which has led to reduced prices. My recommendation is that you should buy only from the website of a gallery or dealer you know, one you're sure is authentic or is related to a reputable brick and mortar gallery.

Buying Directly from the Artist, Online and in Person

There are estimated to be more than 75,000 artists in Canada who produce and sell art as a living, but there are many more artists than there are galleries to represent them. So how do artists promote their work without expensive marketing campaigns? The answer for most is the Internet — using either their own or a shared website to exhibit their work. Even artists who show their work in galleries often have their own websites devoted exclusively to their lives and art. As is the case with the sites for galleries and dealers, artists' websites offer them a huge geographical reach beyond their traditional markets. Since artists are the ones producing the art while everyone else has a stake in selling it, the Internet is opening up vast opportunities for artists to benefit more directly from the proceeds of their work by eliminating many of the middlemen from the distribution chain.

The process of purchasing artwork directly from an artist online involves establishing a dialogue with the artist. You can ask the artist for

the same sales security elements that are available through traditional retail galleries, including taking the art home on approval, satisfaction or money-back guarantees, framing services, resale consignment options, and trade-ins and payment plans. You may or may not get what you ask for, but you should expect prices to be significantly lower than those of similar artworks at galleries.

If the artist is represented by a gallery, he may be under contract not to sell to anyone, whether online or in person, at prices below the gallery's prices. To find out, you can establish a connection with the artist online and see if there are opportunities for you to buy directly, ideally at the artist's price to the gallery, which, as previously mentioned, is usually at least half the retail price. The artist can also inform you of upcoming shows, charity auctions, or other events where their art will be for sale outside of the gallery setting. Some artists who are not represented by a gallery may still price their work close to gallery prices because they feel their art is worth what it would cost at a retail space. (See Chapter 6: Galleries and Art Dealers for more information on retail pricing.)

My wife and I have had the pleasure of meeting some of the artists whose work we collect in their homes and studios. This has sometimes given us first choice on new works and sometimes allowed us to buy art without markups. For example, Bob Fraser is an octogenarian artist in the Beach area of Toronto, where he lives and paints in the same house in which he was born. He was represented by the Victoria Art Gallery on Queen Street until the owner died some years ago. We had purchased a number of his paintings from the gallery when it was in business, but after it closed we went directly to Bob, and since then we have purchased every painting he has finished, with the exception of some commissioned works. One painting of the Canadian National Exhibition, called *Midway*, took him eleven years to complete, and every time I visited with Bob or saw him on the street I inquired about its progress and reassured him that I wanted it when it was finished. One day about six years ago, he declared that it was finally complete. Such can be the joys of dealing directly with the artists. As the late West Coast artist Toni Onley said, "People generally are more interested in my work when they get to know me. Serious collectors like to get not just a painting but a piece of the artist as well." If you see art that

interests you, use a search engine to look up the artist's website and you never know what can happen from there.

Art Fairs

Art fairs have been around since at least the turn of the century and are a feature of cities around the world. Major international art fairs include Switzerland's Art Basel, France's Foire internationale d'art, Germany's Art Cologne, the United States' Art Miami, and the Netherlands' European Fine Art Fair. The biggest art fair in Canada is the Toronto International Art Fair, representing more than one hundred Canadian and international fine art dealers. In the spring, Toronto also hosts the Toronto Art Expo, which features more than three hundred artists representing themselves. Besides these major productions, every city is host to many smaller art shows and exhibitions that usually feature the artwork of a number of local artists. These can be excellent places to pick up pleasureable art at very reasonable prices.

Art fairs give potential buyers the opportunity to experience a wide cross section of art under one roof. Fairs also tend to be very user-friendly, and novice art lovers may feel less intimidated at an art fair than in a gallery. Fairs offer an informal opportunity to meet gallery owners, talk about art, and sometimes meet the artists themselves. You can compare dealers' prices with each other and with auction prices for similar art. But don't be mistaken: some serious buying goes on at art fairs. At the 2006 Toronto International Art Fair, there was a buzz at the Roberts Gallery booth, where a Tom Thomson sketch sold for a reported $500,000. (Weeks later, another Thomson sketch blew that out of the water by selling at a Heffel auction for $934,000.)

For dealers, art fairs are an excellent way to meet thousands of new art buyers, augment their mailing lists, exchange gossip, trade information, and even sell some art in the process. Even though the fairs are expensive for dealers to attend, they find it a necessary part of their annual marketing budget, as beyond the many sales that take place at the fair many also come later as a result of the contacts they have made. "Without fairs, the international art market would be impossible," says Ernst Hilger,

a Vienna-based contemporary art dealer. "With them, dealers can travel to foreign cities and meet thousands of clients in a matter of days."[92] Or, as Picasso's dealer, Daniel-Henry Kahnweiler, once said, "Art we have, it's clients we need." Art fairs provide those clients in spades.

Private Art Dealers

Private art dealers do not run traditional galleries that are open to the general public, but they often have unique and entrepreneurial ways of serving the needs of individuals and businesses around the fringes of the conventional art market. Many private dealers have an extensive network of clients that can include other dealers and galleries. Very often private dealers and galleries buy, sell, and trade with one another, although they can be a secretive bunch, keeping their clients and sources close to their vests. The more established, professional dealers have offices, are listed in the Yellow Pages under "Art Dealers," and have websites that describe their services. My art business falls under this heading, because I buy and sell art to individuals and corporations but do not operate in a traditional gallery setting.

Because private art dealers usually work with much lower overhead costs than galleries, their prices can be extremely competitive. But with private dealers you must also exercise extra caution because, by definition, these dealers do not have to stand up to the same public scrutiny that name brand galleries do.

Fine Art Consultants

Working with a fine art consultant will give you access to expert, *independent* advice, something that is hard to come by any other way. If you are new to the art market or considering a major purchase, working with a professional consultant could save you money by preventing you from making a costly mistake while you are educating yourself and learning the rules of the game. Most fine art consultants do not maintain an inventory of artworks and have no financial affiliations with

artists, galleries, or dealers. They procure art for clients from many sources and aim to avoid any conflicts of interest. Consultants charge for their services by the hour or by a percentage of the art purchased by the client. If they charge a commission on the art they purchase, they may be tempted to sell you a more expensive painting that will result in a larger commission, so hourly or flat-rate service fees are probably the most beneficial and transparent to you in the long run.

Many buyers rely on the judgment, advice, and resources of a consultant for their fine art purchases. A good consultant can find suitable works of art for sale, research artists' biographical and historical information, compile pricing data, and make recommendations on whether or not to buy a particular piece. Like some art dealers, the services of these consultants can be expensive and are not for those with severe budget restraints. Kathryn Minard of Contemporary Fine Art Services, one of Toronto's foremost art consultants, said that one of her goals with clients is to "to set them free on their own course" — to teach them and help them gain confidence in their own choices so that they need her less and less.

Professional art consultants usually have fine art degrees, professional accreditations, and extensive experience. A consultant is often also a certified appraiser licensed to render an opinion on the value of a work of art. Some of the questions that you will want to ask an art consultant that you are considering hiring include:

- Can you provide an up-to-date curriculum vitae?
- What educational degrees and special training have you completed?
- What professional associations do you belong to?
- Can you give me a list of references?
- Do you disclose any possible conflicts of interest?
- What technologies do you use for searching databases of art? Do you have examples of the kinds of reports I will be receiving?
- How exactly do you calculate your fees?

To me most of the fun of art is the self-discovery and the exploration of art and the artists, and it does not take very long to get over the initial learning curve. There is art available at all price levels, and unless you want to start your art acquisitions with first-tier, top-of-the-line paintings, it is

certainly possible, with a little time and effort, to learn most of what you need to know about the art market on your own. As American painter Robert Henri (1865–1929) observed, "The man who has honesty, integrity, the love of inquiry, the desire to see beyond, is ready to appreciate good art. He needs no one to give him an 'Art Education;' he is already qualified. He needs but to see pictures with his active mind, look into them for the things that belong to him, and he will find soon enough in himself an art connoisseur and an art lover of the first order." After all, you have taken the first big step to becoming "art smart" by reading this book! You have to consider your time, motives, and lifestyle to discern whether having an art consultant is right for you.

Here are some professional organizations to which art consultants and appraisers (who are closely linked) may belong:

- International Association of Professional Art Advisors (www.iapaa.org),
- Canadian Association of Personal Property Appraisers (www.cpa-cappa.com),
- International Society of Appraisers (www.isa-appraisers.org),
- American Society of Appraisers (http://www.appraisers.org), and
- Appraisers Association of America (http://www.appraisersassoc.org).

To have an appraisal done online visit one of the following:

- Maynard Elliott Limited (Canada) (www.fineartappraiser.com), a fully independent online art appraisal firm specializing in American art, Inuit art, Canadian art, and European fine art.
- FineArtAppraisal.com, a database of 200,000 Contemporary, Modern, Impressionist, and Old Masters paintings.

Other Venues for Art

Estate sales, garage sales, flea markets, one-time auctions, and special art sales are some of the least likely places to find fine art, but it does

occasionally happen. You may have heard the story of the Illinois rummage sale regular, Roger Olshanski, who bought *Magnolias*, a painting by American artist Martin Johnson Heade (1819–1904), at a rummage sale for less than twenty dollars and later sold it at Christie's in New York for a record US$1,491,000. Your chances of finding a million-dollar painting in a rummage sale are likely slimmer than your chances of winning the lottery.

That being said, I have been the beneficiary of art bargains at charity sales and estate sales from time to time. Estate sales are often advertised in the want ads of your local paper, and because of the necessity to clear things out quickly and inexpensively, you may be able to negotiate a very good price if you know what you are buying. At charity auctions, the fine art for sale has been donated to benefit a worthy cause, and because most in the audience are not aware of the true market value of a painting, it often sells for far less than it would on the open market. Doris McCarthy recently donated an oil painting to a fundraiser at which it sold slightly below retail, and Rolex, a sponsor of the auction, threw in a watch to the highest bidders on the paintings that evening. Nice to get a new Rolex when you buy a painting! So have fun and keep your eyes open for these kinds of venues, and maybe one day we will meet up at Christie's for your million-dollar celebration!

SECTION 3:
BEYOND THE FRAME

CHAPTER 9

Investing in Art

*"My father went to Yale in the fall of 1929, and about a
month later, his classmates' parents started jumping out
of buildings. He was aware of the perils of the stock
market and liked to say, 'Nobody ever jumped out of a
building because their Rembrandt went down'."*
— Victoria Price, art dealer, daughter of Vincent Price[93]

As with any other investment, there are experts who advise for and
against investing in art. The problem lies in measuring the expectations
for return against other traditional investments such as stocks or real
estate. Because of its distinctive and inconsistent nature, there are
severe limitations on any financial advisor's ability to analyze artwork
in comparison to other commodities. There are many statistical analy-
ses of the rise in prices of the art market over the years, and compar-
isons are made between a return on investment in art versus the same
on the stock market, mutual funds, or bonds during the same period.
This information, however, is based on either the art market as a whole
or segments of the art market, from Old Masters to contemporary, by
using all the data from sales recorded at auctions around the world
during that time. An obvious flaw is that these analyses don't include
all the private sales in the world at galleries and through dealers. It is
based on the group sales of one-of-a-kind paintings rather than the
performances of stocks or bonds that can be replicated incessantly and
bought and sold repeatedly on the open market. Some of these indices
that report on the whole market or individual segments of it include

artprice.net, Mei Moses Fine Art Indices, and the Canadian Art Sales Index by Westbridge Publications.

The best that these analyses can do is to advise you where the overall art market and the general markets for particular art movements have been, up to and including the last auctions that were held. They can also tell you, even more accurately, the current standing and strength in the marketplace of individual artists in relationship to the past sales of their work. The difficulty with art is that although trends and prices can be reported, there is little, if any, correlation between fine art prices and stocks, bonds, and other commodities. There is even less predictability in the performance of individual paintings. When economist William Baumol conducted a study on the art market called "Unnatural Value: Art Investment as a Floating Crap Game," published in the *American Economic Review*, his conclusion about art as an asset is that it "will exhibit random behaviour," "float aimlessly," and show "unpredictable oscillations." This is especially true when you look at specific examples rather than at the market as a whole.

Art also has some unique inherent properties that inhibit its ability to be considered a formal investment. It is not a liquid asset and there is not an efficient, readily available, and ongoing marketplace to sell it in, as in the case of stocks, for example. In addition, unlike other assets, there are substantial costs involved in the disposal of art, when you take into account dealer markups and auction house commissions. It is a popular misconception that all paintings are likely to appreciate in value, but actually most don't, particularly those purchased on the primary market. The primary market is the retail galleries and their stable of mostly living artists. Buying on the primary market is buying high, and you will almost certainly end up having to sell low.

Another concern is that art has no universally accepted established relationship between price and product; in fact, there are fewer quality controls with art than with almost any other commodity. As dealer Richard Feigen warns, "The contemporary art scene is certainly prone to hype. While many modern and Impressionist works have had many years to justify their multimillion-dollar price tags, works by current artists commanding high sums have yet to stand the test of time. Because they're expensive does not mean they're the best."[94] Even

though an art collection may involve a huge monetary investment, most financial institutions do not consider it a secure enough asset to lend against. There are also hidden costs to having art, such as insurance, conservation, and storage and transportation expenses, that are not required with other equities. The vast majority of art is definitely a long-term, buy-and-hold investment that rarely appreciates rapidly and often takes many years to dramatically increase in net worth.

Former coroner of the City of Toronto and avid art investor Dr. Morton Shulman realized back in 1977 the difficulty in determining which contemporary artists were going to prove to be worthwhile investments for the future: "The hitch in purchasing modern art is that there are so many artists but so little room for success. When you think that in Rembrandt's time there were over one hundred other artists at work in his city, and when you realize how few of them are even remembered today, you have some idea of the problem. Out of the thousands of modern artists, the work of only the occasional one will survive their own lifetime."[95] Thirty years later and we are still left with the same dilemma. Which of the thousands of artists who are exhibiting and showing today will survive to become sound investments thirty years from now?

The dictionary, however, has many definitions for the word *invest*. Only one of them has to do with putting money into something with the hope of getting a profitable return. It also conveys the meaning of spending or devoting time or energy for a future advantage or benefit. The word actually comes from the Latin word *vestire*, meaning "to clothe or adorn." In that sense, art can be a tremendous investment, both adorning your home or office and, if you have acquired wisely, eventually providing you with a magnificent asset that has significantly increased in value.

Unless you are operating an art investment fund on behalf of wealthy clients, in the art business, or an affluent speculator who buys art for immediate profit, the best way to invest in art is to buy only the art that you love to own. With this strategy you can never lose, because you will have something you love regardless of its value in the outside material world. The truth is that there is great art everywhere, and its value is often independent of its price. For example, a family's photo albums are usually amongst their most treasured possessions, yet they

have almost no real monetary value. Likewise, art, unlike any other commodity, appeals to us for reasons far beyond its monetary value. Art involves our emotions, and with ownership comes pride, prestige, and pleasure. There is the thrill of the acquisition, the pleasure brought by the comments of others, and the joys of becoming a collector. Yes, the art that you love pays you dividends every day!

As the famous poet Arthur Davison Ficke (1883–1945) wrote, "Collectors are buying a lifestyle. It gives them a connection to a dream. Collecting at its best is very far from mere acquisitiveness; it may become one of the most humanistic of occupations, seeking to illustrate by the assembling of significant relics, the march of the human spirit in its quest for beauty." Can you really say you feel that way about your monthly investment report? Why not put at least some of the money earmarked for your RSP towards art? Do you really want to wait until you're sixty-five to enjoy it? The question is, do you have the courage to extend your investment portfolio to include artwork?

There have been historical precedents of art being a safe haven for cash during inflationary or tumultuous times. Ignacio Gutiérrez Zaldivar, collector and co-director of Zurbaran Galeria in Buenos Aires, said, "We Argentines have learned to prefer paper painted by artists to paper money printed by governments."[96] Or, as one commentator observed rather caustically, "There is nothing revolutionary about works of art being a refuge in stormy times. At least investing in art, you won't get an Enron."[97] Actually, you might, if you are swindled by a theft or a forgery, but I know what he meant. Art seems to transcend the temporary upheavals in society and remain a constantly valued commodity.

My philosophy about acquiring and investing in art is that with the proper guidance and knowledge, beautiful art that you own and admire every day of your life can also turn out to be a sound investment over time. At the very least, properly purchased fine art will hold its original value, should you ever need to cash it in or trade up down the road. As Will Rogers said, "It's not the return *on* my investment that I want; it's the return *of* my investment." In summary, my advice to my clients on the subject of art as an investment is to buy for love, but keep an eye on the investment potential by making wise art-buying decisions. You have made a good start to investing in art intelligently by reading this book!

So, how do you begin to narrow the field from those myriads of available and desirable paintings and artists to choose the ones most likely either to increase in value or at the very least to hold their value in the long run?

Your Art Investment Agenda

YOUR EDUCATION AND EDIFICATION

If you have the time and the inclination, the journey of discovery you take when you educate yourself about art can be a very joyful and spiritually uplifting experience. As you learn more about art, you will likely learn more about yourself at the same time. Since you are reading this book, let's assume that you are planning to experience the pleasures of purchasing and researching art mostly on your own.

The most important activity you can pursue in furthering your art education is to look at as much art as possible, wherever it is being shown. This would include visiting private art galleries, public museums and art galleries, art fairs and shows, and all types of auctions and browsing online galleries. It might be good to start with the public art galleries that contain the best examples of fine art, including some masterpieces, to set your standards high from the beginning. Look, look, look!

Try to figure out exactly what it is that you like, or dislike, about all the art that you see. Only by making comparisons can you refine your taste. Comedian and art collector Steve Martin said, "I am not sure I ever acquired taste, but what I have is a feeling for art. This feeling is not absolute; it's relative. It came to me not as a blast of intuition, but through the viewing of hundreds of paintings, and sorting them into a vague and fluid hierarchy."[98] I have observed that there is a lot of thinking around art and that should not have to be the case. The more you look and compare, the more your tastes will be refined and you will learn which artists and art periods you like the most. As Andy Warhol said on a similar subject, "My instinct about painting says, If you don't think about it, it's right. As soon as you have to decide and choose, it's wrong. And the more you decide about, the more wrong it gets."

When I was young my parents bought some Blue Mountain pottery from Collingwood, Ontario, and I remember thinking how beautiful it was, but I tired of it quickly and actually grew to intensely dislike most of it. Why was that? My tastes had changed and matured through comparisons with truly beautiful works of art that had stood the test of time. "Such experiences have confirmed my belief that one's most deeply entrenched taste is the acquired taste, whether it's for art, avocados or comedians," Martin said.[99]

When you visit galleries, do not be afraid to ask questions, especially of the gallery owners themselves. They are in the art education business and are only too happy to discuss both their art and artists and the art market in general. Ask them about investment potential for their artists and which ones are most likely to appreciate over time. This is your best source of free information, because these professionals have seen more art in a year than you will probably see in your lifetime. Watch for the visual impact the artist's work has on you. Does it move you? What types of art are you drawn to and why? Pay extra attention to the works that challenge you and that you find hard to grasp at first or those that take your breath away and shut down your rational thinking, if only for a few seconds. If a work sticks in your head for a while, go back and see it a second time or make an appointment to see more by the same artist. You're probably getting closer to defining what you like.

Looking and asking gives you the opportunity to compare from aesthetic, price, value, and quality standpoints. Experts at the large auction houses also have a wealth of information not only because of their formal art training but also just because of the tremendous amount and variety of art that they work with every day. Besides the actual sales, where every piece has to be vetted for authenticity and value, people constantly bring in artwork for appraisal. These experts have seen a lot of art, even if they seem a little less than enthusiastic about any one piece or artist. (I have found this often to be the case — it may be because it's only a job to them and not a passion, or because at auction houses price is the only consideration, or perhaps because the sheer volume of works they deal with dulls their enthusiasm.)

After looking at enough art to figure out what you like, you may want to draw up a list of artists and art movements and periods that

appeal to you and study up on the artists' lives and histories. Whether they are living or dead, there is probably information about them in libraries, bookstores, or on the Internet. Books are the best sources for the history of art and art movements.

There are a number of newspapers, magazines, and reports that are really informative and necessary for anyone wanting to keep up to date with the world of art and auctions. You can either subscribe to these or visit your local library to see if they are kept in stock there. My favourite international magazine is *Art & Auction,* which covers the auction scene and has many well-written and -researched articles on the art market in the U.S. and around the world. There are many others full of useful information. See Appendix C for a list of some of the most useful print and online resources for information on art, artists, and the entire art market from around the world.

RESEARCH

After you have started the process of educating yourself about the world of art, you will need to have the tools to do specific research on any particular artwork that you are considering purchasing. What was previously available only to the exclusive world of the art appraisers, the very wealthy, and academics is now, thanks mostly to the Internet, readily available, transforming the art market into a very open and transparent marketplace. Some people have referred to this revolution as the "democratization of the art world." Everyone who is interested in fine art as an investment recognizes the value of due diligence in confirming the authenticity of the work and establishing comparative and market value. Most of the information on the Internet is available on a subscription basis; the printed reference materials can be purchased or borrowed from libraries. The information can be extremely detailed, covering everything from the artists' biographies, their dealers, and the complete history of all past auction results, including size, medium, date of sale, and price of each piece sold. You can even see samples of artists' signatures and have an artwork appraised online for a market value assessment.

When you are using a search engine to research art or an artist, be sure to use *and* or *or* between the relevant search words to maximize your

chances of finding all the information you need. You may want to use the advanced search option, if available, and if the database has limiting material options that could, for example, search only for feature articles, you may eliminate hundreds of irrelevant hits. The Internet is loaded with art research sites. Two of my favourites are artprice.com and artnet.com.

The best database for Canadian auction records is the auction price index found at www.heffel.com, which is a subscription-based site that will give the historical record of results of Canadian art at auction. Artist reference resources include www.Art-in-Canada.com, www.Canadian-Artist.com, www.CanArtScene.com, and www.CanSculpt.org.

The granddaddy of all art reference books is the fourteen-volume *Benezit*, costing about US$1,500. When first published in 1911, the *Benezit* immediately became a vital source of documentation for art historians and art dealers. Today it owes its reputation partly to its staying power but also to the quality of its information. The new English-language edition took five years to create. It includes more than 170,000 artists' biographies, 15,000 signatures and monograms, auction records, museum and gallery listings, and descriptions of all listed artists' main works and biographies.

See Appendix C for many more print and digital art resources.

Buying Your Art

You are now prepared to make the leap from art lover to art possessor. As Duveen's biographer S.N. Behrman observes, "In all love affairs, there comes a moment when desire demands possession."[100] But what are the general guidelines to help you in your quest to own art that you love but that will also have the potential to hold or increase in value? I believe Miriam Shiell of Miriam Shiell Fine Art, one of Canada's leading dealers, expressed it very well when she said, "It is very North American to think: I've bought art, I spent the money, it's gone. Europeans tend to understand that art is a long-term store of value. The money isn't wasted. You've moved it from one cookie jar to another. You've put value into your life, long-term value into your asset portfolio. ... My advice to new collectors is to get the best advice you can, and then make an intelligent, informed decision, but make a decision that comes from the heart."[101] Or,

as my good friend and mentor, art appraiser Daniel Zahaib, said, "You are not spending money when you are buying fine art."

Here are some general principles for what types of art are most likely to either hold or increase in value, but buying art should not be a cold or calculated decision based on economics. Besides buying what you love, the overall quality of the artwork is the single most important consideration. Through your education and edification journey you have decided which mediums and price ranges you want to invest in. Whether you have chosen paintings, prints, photography, or new media, you are going to try to acquire the best that you can afford. Surprisingly, many studies have shown that lower priced art actually outperforms high-priced art, and therefore you do not have to buy masterpieces to achieve above-market returns. You do not have to be wealthy to acquire fine art; you just have to have the right information and a willingness to learn.

The best group to look into for investment purposes is what is called second-tier or third-tier artists. These are listed, name brand artists who have a history at auction and who for some reason have been either ignored or overlooked. The first-tier artists are the ones that everyone is going after, and their prices have already skyrocketed. Purchasing those would be the equivalent of buying stocks at the high end of the market. Now, determining the upper end of a market is not very difficult, but one thing is for sure: it's risky and expensive to be in that stratosphere. You can win big and lose big in this arena! In studying auction results of the high-end market, I have seen it go both ways for collectors. Sometimes they make huge, multi-million-dollar gains in a relatively short time, and sometimes they suffer multi-million-dollar losses on what seemed to be sure bets. But if you can see trends developing and buy around the edges you can make some impressive gains. An example of this was with Lawren Harris's abstract paintings. While his mountain and iceberg images were soaring, his abstracts were still affordable for a long time, and now they have taken off as well! It was the same with the Beaver Hall Group and Canadian women artists in general. They were undervalued for decades and now are beginning to receive the recognition and prices they so richly deserve. (I can remember when a Prudence Heward painting was very affordable!)

What happens is the first tier reaches heights that so few can afford that art buyers start looking around for the next group that they can afford, and so on. According to the 2006 edition of the Canadian Art Sales Index almost 66 percent of all Canadian paintings sold at auction in the 2004–05 season went for less than $2,000, and 52 percent sold for less than $1,000.[102] Most paintings at auction sell for less than $1,000, with probably a slightly higher average at the best sales. There is still plenty of great art available for the picking at very reasonable prices in this secondary market. The Canadian art market has many quality artists who have not yet reached their full potential. For example, as long as I have been in the art business, everyone has been talking about the potential for future gains with the Painters Eleven. At the auctions in the fall of 2006 some of that group were starting to live up to their expectations.

Watch for shows or publications highlighting secondary artists, as these could be an indication of a renewed interest in them. The death of an artist is no guarantee of a rise in prices; in fact, most artists are forgotten long before they die, and it takes a curator, a publisher, or an institution to bring them back into the public consciousness. Some criteria to watch for: Were they prolific? Did they have serious curatorial support? Is information about them widely available? Did they exhibit widely during their lifetime? These are the artists who have the most potential in the aftermarket to become the next members of the first-tier club. There are just so many underpriced and relatively unrecognized second-tier Canadian artworks available at auction at reasonable prices that you have to identify the ones that are moving up as they start to break away from the pack. It is similar to picking stocks: watch for the ones with rising volumes and prices and a renewed interest through publicity or media attention in one form or another.

Note what one prominent dealer, Ronald Augustine of the Luhring Augustine art gallery in New York, advises:

> There is still a tremendous amount of wealth in the world. My sense is that blue-chip collectors will behave as they have historically and continue to acquire blue-chip art. It's a safe arena for them, and they feel very comfortable within it. … The emerging markets for

young artists will also be relatively unaffected as there is a low degree of financial risk. The market to watch will be the middle market. Inflated markets for some artists will most certainly evaporate, but there will be opportunities to buy very advantageously in this area.[103]

As they say, hindsight is 20/20. Let's go back in time and read how legendary Canadian art dealer G. Blair Laing describes the prices for Group of Seven artist A.J. Casson: "During the 1940s we showed paintings by Casson but even at minuscule prices they hardly ever sold. Our records indicate that as late as 1957, the most we received for one of his large works, a splendid canvas of 1926, was $750. In 1958, when he retired from Sampson-Matthews, after working there for thirty-two years, we were still offering his small panels at $50 each."[104] And catch this recollection of his concerning Tom Thomson sketches in light of their current million-dollar-plus value:

Charles Hendry, a former Dean of Social Studies at the University of Toronto, records in a privately published essay that my father sold him a [Thomson] sketch in 1941 for $300, payable at $10 per month with no interest. During the forties prices were stable, at $300 for a good one. By 1954, it was $500. On September 7, 1956, Robert McMichael bought a sketch, Pine Island, Georgian Bay, for $1,000. It was his first Tom Thomson acquisition, and he tells the story of how he and his wife Signe sat down and wrote out ten post-dated cheques for $100 a month to pay for it. Prices of the sketches remained at $1,000 until 1960, and by 1963 were only $1,500.[105]

Just a few years ago, these and many other first-tier Canadian artists were affordable, but not any more. You have to look at the art that is presently undervalued for the contemporary artists that will be highly valued in the future. A fairly safe assumption for investment return is that high-quality art from recognized artists with strong name brand recognition will continue to appreciate in value, provided you

are prepared to weather the periodic recessions and plateaus of the art world. The best place to find these artists is at auctions, either online or in person, or from reputable dealers who specialize in your desired medium or who have this art as part of their inventory.

Personally, I find that auctions, especially the minor ones from good auction houses, supply the most opportunities to pick up a bargain. If you live in Toronto, Waddington's "Off the Wall Sale," held once a month, is a fun and exciting sale that proceeds at a rapid-fire pace, and in just a few hours hundreds of paintings and other artworks are sold at rock bottom prices. Ritchies also has monthly "Discovery Sales," which feature almost everything, including estate art pieces often sold without reserve and at very low prices compared to retail. Look for these types of art auctions in or near the cities where you live if you want to buy some art at less than wholesale prices.

In contemporary markets, you want to support young, up-and-coming artists whose work is promoted by first-class galleries. There is usually a buzz about them, but beware of too much hype. Marques Vickers accurately sums up the reality of your chances of successfully picking the artistic winners of today that will still be sought after in the future: "History as it applies toward the fine arts industry is littered with the carcasses of the next big thing, and recognition is one of those intangible mistresses embracing and discarding with equal abandon. The occasional few collectors who seem to possess an eye or the magic touch for spotting future talent generally are wrong nearly as often as they are periodically correct."[106] In the world of contemporary art there just are no guarantees, no sure bets.

It is better to find a living artist or artists that you love and go along for the ride as their dealer moves their prices up as they achieve increased sales and inclusion in prominent collections and are featured in public art gallery shows. In any case, the major galleries are the depositories of the best and the freshest art that money can buy. Even though you are paying retail, they often have the goods, and sometimes you just have to pay what the dealer is asking if you want what they have badly enough. Just bite the bullet and buy! After all, you are supporting not only the gallery but also living, working artists who very much need your financial support to keep on producing their art.

You must be prepared to buy and hold to realize any real gains, but you will find joy, prosperity, and rewards while you are waiting. Don't be so overly cautious that you fail to take a risk, just make sure it's a calculated risk, not a reckless one. Ron Davis advises, "If you've found a painting you like, in good to excellent condition, in a school of art that is appreciating, fairly priced, you've done your research and due diligence, and it's affordable, buy it! Enjoy your painting for its beauty and financially for its profit appreciation for years to come."[107]

Do not let anyone, even your lawyer or accountant, talk you out of buying a great painting that you really want to own. In his memoirs, G. Blair Laing relates the following interesting and cautionary tale:

> Peter Eilers was a tenacious salesman, correct and patient. I remember him once staying up until four o'clock in the morning at Moffat Dunlap's house on Forest Hill Road. ... This particular evening Eilers was showing him Van Gogh's *Iris*. ... This price was $65,000 ... in a state of self-doubt, [Dunlap] telephoned his lawyer, a partner in an old conservative law firm, who advised against it. "Too much money for any painting," the solicitor said.[108]

He ended up not buying it based on his lawyer's advice. Van Gogh's *Iris*, for God's sake! For that price — what an opportunity! If only they could have seen the future and the multi-million-dollar price tag that painting would attract today! Ironically, that purchase, had he made it, very well could have been the most astute investment Moffat Dunlap made in his whole life.

My standard saying is that there are three types of paintings: the "Oh" — ones that make you notice, the "Oh my" — ones that really capture your attention and stop you in your tracks, and the "Oh my God" — the ones that take your breath away and pierce you to your soul. The "Oh my Gods" are the ones to buy! When you buy these paintings, whatever the cost, you have purchased a bit of eternity for yourself. You will never regret it. You can and will always have more money, but when you come across a prized work of art — what price can you put on the

priceless? Emily Carr wrote, "A picture is not a collection of portrayed objects nor is it a certain effect of light and shade nor is it a souvenir of a place nor a sentimental reminder, nor is it form, nor yet is it anything seeable or sayable. It is a glimpse of GOD interpreted by the soul. It is life to some degree expressed."[109] It is very difficult for anyone to assign a monetary value to that!

Selling Your Art

It has been said that art is money. At some point in time and for a host of reasons, you may want to or have to sell some or all of your art. As with stocks and all other commodities, this is when you will realize your true loss or your true gain; everything else was speculation. The good news is that there will always be willing buyers and sellers of art to create a marketplace, establishing fair market value for a painting. Also, as cultural institutions continue to take the best pieces and individual collectors compete for the very best pieces, the premier artwork is constantly decreasing in circulation. If you own any of these sought-after pieces, then you and your artwork will be in demand.

The reasons people sell artwork vary greatly; at auction houses the reason is often one of the three Ds: death, divorce, or debt. It can also be due to the demands of the collection, such as upgrading or selling certain pieces that do not fit or, quite simply, that you have outgrown. One of my art friends sells a few paintings every now and then to augment his retirement income. The question is not so much why one needs or wants to sell as how, when, and where are the best places to sell a painting should the need arise. Your choices are dealers, online or through traditional print media, cultural institutions, or auction houses, depending on how much time you have and the worthiness of the artwork you have to sell.

Most people sell art through auction houses. It opens your art up to an international audience and gives it the widest possible exposure. But as explained there are substantial costs involved, and it may take up to six months to receive your cash from the day you assign it to the day it is sold. If you offer up a painting at auction and it does not sell, it is

considered "burned" and must be taken off the auction market for at least five years, at which point it will again be considered "fresh" to the market, or sold elsewhere. Auction houses can give you a preliminary estimate within two or three days, and they will decide which showrooms around the world are best suited to sell your art. The dealer that represents the artist may be interested in buying your painting, but at wholesale prices, so he can sell it again at retail. However, you will make more money selling your art directly to a collector, investor, corporation, or museum through either the Internet or traditional want ads, although it will probably take more time and considerably more effort.

The art market has two definite seasons: late September through Christmas and late January through the end of June. Auction houses have schedules and deadlines that are published in advance of any sale for the consignment of any artworks. Most of these are posted on their websites. If you want to avoid even longer delays, you will have to check their schedules.

In truth, I don't really like selling paintings at all. I am more a collector than a dealer. It is sometimes difficult to buy paintings strictly for resale, although that is the nature of the business. I read an article about a man who was an art dealer in Toronto for almost forty years, and his advice to his son was, "Don't fall in love with the merchandise." That's the problem, these paintings become like children, or at least a part of the family, and it's hard to let them go. I once asked art dealer David Loch about his own personal collection, and he replied, "I don't own that much, I search out all the best ones for my clients." Spoken like the consummate dealer that he is! I think more like artist Damien Hirst, who was quoted in the *National Post* as saying, "To buy art to invest, you would have to know a hell of a lot about it, and if you know that much about it, you'd be seduced by the whole ethos of it and you would not want to part with it. Once you start trading it for money, you lose the art and just get the money back instead, which is crap — a bad deal. You buy a great painting; you've got a great painting. If you sell it, you're fucked."[110]

CHAPTER 10

Collecting Art

*"One of the great things about art is that it's a celebra-
tion, and a collection is a celebration of a celebration."*[111]
— artist Damien Hirst

It has been said that you know you are a collector when you have more
paintings than wall space. However, a collection of fine art is so much
more than just a random quantity of pictures. As Duveen said to Julius
Bache of Prudential-Bache Securities when he bought an expensive art-
work that was outside his collection, "Julie, an accumulation is not a col-
lection. Concentrate!" A collection has a theme running through it that
creates an attraction that goes beyond the individual pieces. The collec-
tion begins to take on a life and strength of its own. There are so many
diverse ways to begin collecting; it really is a personal choice, as only you
can know what interests you and captures your attention. It can be a
single artist, a school of art, a series of prints, a historical period, a type
or style of art, portraits, miniatures, subject matter, or anything else. It
would probably be prudent to start with someone or something that is
currently out of favour and not sought after by other collectors.

All great collections must have their genesis in passion and desire
and not primarily with the expectation of some future economic worth.
"The more freedom you have from considerations of market value, the
more successful your collection," advises German collector Harald
Falckenberg. In fact, the quality and the rarity of the collection should
be the only criteria, and if you follow that path, then it most likely will
have a sound economic value one day as well.

Collectors become experts in the fields of whatever they are collecting. They often know more than the dealers and curators put together because they have concentrated their efforts in one direction. Some use the collecting as an opportunity to get to know their artists intimately, perhaps meeting them if they are still living, or travelling to the places where they painted or lived in order to soak up some of the ambience. With each discovery, they learn more and more about what was going on in the mind and heart of the painter and in society at the time, and life becomes deeper and richer because of their explorations. In my opinion, becoming a collector is the pinnacle of investing in art, because you have now combined passion with expertise. There is an immense joy in putting together a cohesive collection of one or a number of artists or periods or styles of art. Collecting adds focus, intensity, and an increased measure of excitement to the obsession of acquiring art. Collectors are always on the hunt for the next trophy in their collection. They often experience intense desire to attend multiple art functions and sales, as well as, art dealer Yves Trepanier observed, a "willingness to go to the outer limits of their existence and … to ruin themselves financially for the love of what they are collecting."

Collectors are driven by passion, and collecting quickly becomes a way of life. They must have certain works of art; it's not a maybe, it's a driving force that motivates them to add that next piece. The art and the collection take over their lives; the collection begins to take on a life of its own as it moves towards its ideal form. Slowly and surely, as one grows in knowledge and appreciation of art, there seems to be a connection between all the pieces within the collection and cohesion to the group as a whole. Now, not only do individual pieces of art attract you, but also the full force of the collection acts in tandem with your desires to possess you. This irresistible pull in part explains why at auctions some pieces are fought over seemingly without limit until the winning collector gets his prize. It's not an acquisition but an obsession. This force can have a profound effect on the collectors as they experience the transformative power of art to connect with the unmanifested world behind the world of form. As Mahatma Gandhi said, "True art takes note not merely of the form but also of what lies behind it." Through the collector's intense relationship to art, he now can feel what Einstein said

was the most beautiful thing we can experience — "the mysterious. It is the source of all true art and all science."

Total immersion into art allows us to feel the connection to the divine source that connects us to all living things. Being surrounded by a collection of art not only enriches your visual experience but can also uplift your spirit to new dimensions that can help you to transcend the illusions of everyday realities and self and become more closely connected to the divine.

What are some of the practical benefits of becoming a collector? Besides personal enjoyment, by building a quality collection you can add to the stature of the artists and help others to see their work as a whole and not as an isolated event. You become an expert in their art and lives and thereby are aware of what their best work is and what constitutes a true masterpiece when you see it. Without collectors to value, admire, and desire their artwork, it can quickly pass on to obscurity as the newest or latest takes its place. In other words, collectors preserve the interest and legacy of artists by introducing their work to the rest of the world and to future generations. Many artists are way ahead of their times, and collectors sustain an interest in them until everyone else catches up and sees what they saw and we all realize what valued artists they are or were in their time. You actually help to set standards and influence trends in the artistic community and the country.

A collector of art is an important link in the preservation of one's own and a country's history. Collectors not only possess but also preserve and care for artwork that may have otherwise disappeared or disintegrated. Collecting is the irreplaceable link between the heritage of the past and the living culture of today. Collectors often donate their excellent artworks to public art institutions, either before or after their deaths. This immense contribution to the cultural heritage of the cities and countries where they live becomes part of their legacy. It was always a pleasure to see Ken Thomson at art previews and to watch him contribute significantly in raising the values and appreciation for many Canadian artists. Canadians are going to benefit richly from his passion for art, as he has donated most of his collection to the Art Gallery of Ontario. Joey and Toby Tanenbaum, also famous and generous collectors, gave their collection of nineteenth-century European art to the Art

Gallery of Hamilton. The collection is valued at between $75 million and $90 million. Many other collectors have left their treasured collections at institutions across Canada, and we would be a poorer country and civilization, both spiritually and materially, without them.

For me and my wife, our collection just happened as we started to buy more and more Doris McCarthy paintings. After we owned a few and had learned more about her remarkable life, we realized that there were periods, styles, and mediums that we lacked, and so the hunt to fill the gaps began. It became a thrill not only to have more but also to try to get the best from each period and style. Eventually, we became known as fans and collectors and we were asked to lend pictures for group exhibitions that were held at various galleries across Canada, from the McMichael Collection in Kleinburg, Ontario, to the Varley Art Gallery in Markham, Ontario. It is a dream of Doris's and many others to have the National Gallery of Canada and the Art Gallery of Ontario honour and recognize her with a show to mark her hundredth birthday in 2010. She said she would make sure to stay alive until at least then, so she could attend the opening! I would someday like to show her work to our American neighbours and around the world as well. (With global warming, icebergs and glaciers — some of Doris's favourite subjects — may someday be a thing of the past.) Presently, however, it is a pleasure to share our passion, knowledge, and art with others and to experience their joy and appreciation for her work and for our collection.

Now that you have become a collector, what do you do with your collection? The next chapter discusses some of the options that are available to you both now and in the future.

CHAPTER 11

Donating, Taxes, and Succession Planning

"The essence of all art is to have pleasure in giving pleasure."
— Dale Carnegie

What to Do with Your Collection

After many years of collecting, you may find yourself with a lot of paintings and artworks that you would like to pass on to your heirs or donate to society at large. This chapter will give you some options to consider and explain the potential benefits of each. You will want to discuss them with a qualified lawyer, a financial planner, or an accountant who can explain up-to-date tax benefits and relevant laws and give you expert advice particular to your situation.

Donating Art as a Certified Cultural Property

Although selling your art would probably give you the biggest economic return, there may be some tax advantages in donating all or part of your collection to a designated Canadian cultural institution. The value of the donation is determined by the rules and guidelines as outlined by the Canada Revenue Agency. Traditionally, the CRA has defined fair market value as "the highest price obtainable in an open and unrestricted market between informed and prudent parties, acting at arm's length, under no compulsion to act, expressed in terms of money, or money's worth." It also sets out a number of factors that should be taken

into account in valuing a work of art, including the artist's education, exhibition record, and reputation; his or her sales and auction records; specific market demand; the medium, size, production date, quality, and subject matter of the work; and comparable prices of similar works by other artists with similar experience. Often the best evidence of true fair market value is the price the donor paid for the work plus some potential market value appreciation over time.

In 1976, the Canadian government enacted the Cultural Property Export and Import Act and related amendments to the Income Tax Act so that citizens who donate culturally significant works of art to designated institutions will receive more favourable tax concessions than those given for most other types of donations. Qualified gifts are eligible for a non-refundable federal tax credit based on the fair market value of the artwork. Under the Cultural Property Export and Import Act, 100 percent of the current fair market value of the property on the date of donation can be used as a tax credit. This tax credit can be used to offset the total amount of the donor's net income. If the fair market value of the gift exceeds the donor's total net income for the year, the remaining tax credit can be carried forward and claimed during the following five years. Unlike charitable donations, with certified cultural property the donor is exempt from the payment of capital gains tax resulting from the gift. In addition, any appreciation in value is not recognized as a capital gain and the net income limitation that applies to most other forms of donation does not apply.

The value of the gift is determined by the Canadian Cultural Property Export Review Board, an independent tribunal of the Department of Canadian Heritage, or by the Commission des Biens Culturels in Quebec. This tribunal consists of museum curators, archivists, and art gallery owners, as well as collectors and private dealers. Their mandate is to determine whether or not an artwork is of "outstanding significance and national importance" and to assess the fair market value of donations to designated Canadian cultural institutions. Surprisingly, the donations do not have to be Canadian in origin to be eligible.

To donate, you must have a signed deed of gift provided by the institution prior to December 31 of the taxation year in which the donation is made. Then, the designated public institution receiving the gift

must apply with the donor, or on behalf of the donor, to the review board to have the gift certified as cultural property. This application, which is usually prepared by the cultural institution, must contain documentation arguing on behalf of the work's national cultural significance along with an appropriate appraisal of the current fair market value of the work. You should ask your lawyer or accountant for further information and updates, or you can start by logging on to the CRA website, www.cra-arc.gc.ca, and searching for IT-110R3 Gifts and Official Donation Receipts, or by contacting the Review Board secretariat at revboard_sec@pch.gc.ca.

If you decide to sell some of your collection outside Canada, you may run into a problem if one or more of the works is deemed to be of national significance. For such works, the board will issue export permits only if no Canadian buyer is willing pay fair market value. The review board meets approximately four times each year and reviews about 1,500 applications. Of these, approximately 70 percent are for art and 25 percent are for archival material. In one famous case, a rare Paul Kane (1810–1871) painting, *Portrait of Maungwudaus*, was sold by Levis Auctions in Calgary to a bidder from outside the country for $2.2 million. The board held up the sale for months looking for a Canadian to match the price, but eventually an export permit was issued.

To be eligible to have cultural property certified, an institution or public authority has to be designated by the minister of Canadian heritage at the time the legal transfer of ownership is made. Designation ensures that institutions receiving cultural property have the appropriate measures in place to collect and preserve it and to make it accessible to the public for research or display purposes. Category A designation status is granted indefinitely to those cultural institutions that are well established and that meet all of the criteria for designation. Category B status is granted exclusively in relation to the proposed acquisition of a particular object or collection to institutions that meet the criteria for designation and that have shown their capability to effectively preserve the specific property in question. The Doris McCarthy Gallery at the University of Toronto at Scarborough is currently applying for designation so that it will be able to receive gifts of cultural property and provide donors with the appropriate tax benefits.

If you are considering donating a work of art, please visit the gallery's website at www.utsc.utoronto.ca/dmg or phone (416) 287-7007.

Donating Art as a Charitable Gift

Because of the complexities of donating through the certified cultural property method, and depending on your income and the appreciation of the artwork, you may want to donate under the income tax provisions for regular charitable donations as set out by the CRA and the Income Tax Act. It is very important to consult an accountant who fully understands this part of the Act before proceeding, because there are many variables and subtleties depending on your status and financial situation at the time of the donation.

Before donating some or all of your art as a charitable gift, you have to consider the following guidelines:

- The gift has to be a voluntary transfer of property to a qualified charity without an expectation of any return. Because you are not giving cash, your donation is called a "gift in kind." A gift in kind can be issued an official tax receipt for the donation's fair market value, which is defined as "the highest price that the property will bring in an open and unrestricted market between a willing buyer and a willing seller who are knowledgeable, informed and prudent, and who are acting independently of each other."

- The charitable receipt must contain 1) a statement that it is a charitable receipt for income tax purposes; 2) the charity's registration number as recorded with the CRA; 3) the place where the receipt was issued; 4) the actual date the gift was received; 5) the amount of the gift; and 6) the name and address of the owner.

- These donations are eligible for a tax credit and are subject to limitations based on the donor's net income. You receive a federal tax credit equal to 17 percent of the first $200 and 29 percent of any amount in excess of $200. These credits can result in a significant reduction

of your federal and provincial taxes. You can carry forward any unused charitable gifts and claim them for up to five more years, as long as you claim an amount or portion of an amount only once.

- If you are in the art business and you donate one of your paintings, the gift has no capital gains tax implications. The CRA considers these gifts part of your inventory, not capital property or personal use property. They consider the proceeds to be business income based on the gift's fair market value at the time it was donated. You can claim a tax credit if it otherwise qualifies. If you are an artist, the CRA usually considers any works you create and own to be inventory and not capital property. Where it is donated can affect the tax credits. You have to report any capital gains or losses on your return for the year in which you gave the gift. To determine the gain or loss you would need to know the fair market value, the adjusted cost base, and any outlays or expenses incurred to donate it.

Tax Consequences of Selling Art

As an individual selling art, it is necessary to calculate and pay the taxes on the increased capital gains or claim the difference as a capital loss, under the same terms and rules that apply when donating works of capital property as discussed above. Capital gains realized on the selling of your personal property, such as art, are not taxed when the proceeds or deemed proceeds do not exceed $1,000. Art is a good investment vehicle because the appreciation when you sell is taxed at the more favourable capital gains rate, whereas many other investment revenues are taxed as income.

Art and Business

Many businesses invest in art to beautify their offices and make a statement about their corporate identity. Certainly having beautiful art or art that complements your company's image in the office can add greatly to the

interest and enjoyment of visitors, clients, and employees. There is also a tax advantage to filling your walls and boardrooms with Canadian art. Businesses can claim capital cost allowances at a rate of 10 percent the first year and 20 percent per annum after that of the original cost on a declining balance basis on art created by living Canadian artists. The Income Tax Act requires that the art purchased have a cost of $200 or more, and it cannot be written off immediately against income but must be capitalized and written off in accordance with the capital cost allowance regulations. You cannot buy a painting for your office and deduct the cost as a business expense, but there are no restrictions on capital cost allowances as long as the art was created by a Canadian artist. According to the CRA, art done by a non-Canadian is excluded from the capital cost allowance system because art objects typically do not depreciate but appreciate in value! Now you have it: the CRA has confirmed that art is a good investment.

Succession Planning

The cornerstone of estate planning is the last will and testament. A proper will can minimize taxes payable on death, easing the burden on your heirs. Keep in mind that the tax treatment for an artist's inventory will be different from the treatment for an art collector and different again for an individual or company engaged in the business of selling art.[112] So don't delay in planning your estate.

In his book *Art, Law and the Community*, Toronto lawyer and art consultant Stephen Smart advises that in considering succession planning, you should keep in mind the following issues in regards to your art collection:[113]

- deciding whether to pass your art on to the next generation;
- deciding whether a collection should be split up or allowed to remain intact;
- deciding the eventual destination and ownership of the art collection;
- determining whether there is any interest in using the collection as an education tool;

- exploring how taxes can be minimized on assets both while living and after death;
- establishing whether artwork should be gifted or sold to reduce outstanding debts or other estate liabilities; and
- managing inventory to maintain appropriate price levels and to increase the reputation of the work and its importance to the cultural life of the community.

Four of the more common techniques for dealing with these issues are:

- establishing gifts,
- setting up trusts ("inter vivos trusts"),
- planning the estate through the last will and testament, and
- naming an art executor.

You may also give a gift of artwork to a charitable institution and keep it in your possession for the balance of your lifetime under certain conditions of a charitable remainder trust (CRT). A CRT is an estate planning tool that gives donors the satisfaction of making an irrevocable gift today while continuing to enjoy the property during their lifetime. The tax and estate planning issues involved with a CRT are very complicated and should only be entered into under the guidance of an accountant and lawyer familiar with this kind of donation.

No matter which course you select, the important thing is that *you* decide what will happen to treasured artworks both while you are alive and after you pass on. Joseph Duveen inculcated into his clients that by buying fine art from him they were purchasing immortality. Yes, a collection of fine art, preserved for your loved ones or for the community, is a meaningful legacy to leave behind.

Theft, Scams, Insurance, and Copyright

*"It's not that the art world denies the existence of
thieves ... but the subject is so unseemly, the yoking
together of the words 'art' and 'crime' ... the sublime
and the grimy, that the art community tends to avert its
eyes and hope the whole nasty subject will go away."*[114]
— Edward Dolnick, *The Rescue Artist*

No serious collector wants to own or have in his possession artworks that were either stolen or obtained by some illegal means. Today, more than ever, collectors of fine art have to make sure that they have proper title to their art and that it was legally acquired. There are many art scams out there that you need to know about and avoid. You have to take steps to insure your collection properly, and finally, you must learn what copyright protection the artist has with regards to art that you own. This chapter will discuss all these subjects, with the intention of preparing you to discuss them in depth with qualified licensed professionals.

Thefts and Art Scams

In January 2007, thieves stole from the Ontario College of Art & Design in Toronto a painting by J.W. Beatty, an oil on canvas called *Winter Sunshine, Bellefountain*. In 2000 it was appraised at about $25,000, and it has probably appreciated significantly since then. Beatty, a contemporary of the Group of Seven, was invited by Arthur Lismer to teach at what was

then called the Ontario College of Art in 1912, and he taught there until 1941. Beatty's works are included in the National Gallery of Canada and the Art Gallery of Ontario. As of February 2007, the painting was still missing. In January 2004, five eighteenth-century ivory sculptures that belonged to billionaire Ken Thomson were stolen from the Art Gallery of Ontario. The artworks, worth $1.5 million, were eventually recovered and deposited rather mysteriously at a legal firm in Toronto.

Some of the world's most famous artworks have been stolen, including Leonardo da Vinci's Mona Lisa, which was taken from the Louvre in August 1911 by Vincenzo Peruggia, a former employee of the Paris museum. Peruggia, who claimed he wished to repatriate the work to Italy, was discovered trying to sell it to the Uffizi Gallery in Florence about two years later. In fact, in his book *Stealing the Mona Lisa*, Darian Leader notes that the theft contributed greatly to the Mona Lisa's fame, as more people came to see the empty space where it had been than had come before to see the painting. And who has not seen the images of the art thieves hightailing it across the front lawn, in broad daylight, of Oslo's Munch Museum and loading Edvard Munch's masterpieces *The Scream* and *Madonna* into the open trunk of their car? In 2003, two men posing as tourists stole Leonardo da Vinci's *Madonna with the Yarnwinder* from Drumlanrig Castle in Scotland. As they escaped out a window and down an outer wall, they reportedly told two New Zealand tourists, "Don't worry, love, we're the police. This is just practice." It was probably stolen to order and would likely fetch close to $100 million in today's market. It has not been recovered to this day.

In March 1990, one of the biggest art thefts in history took place at the Isabella Stewart Gardner Museum in Boston. Two men disguised as police officers duped and handcuffed the security guards before making off with three Rembrandts, a Johannes Vermeer, an Édouard Manet, and five Degas. At the time, the haul was estimated to be worth about $400 million. None of it has ever been recovered.

Actually, only 10 to 15 percent of all stolen artwork is ever recovered. In fact, there are comparatively few trials and even fewer convictions for art theft. Most art, evidently, is stolen by request or to be used as collateral for illegal drug deals or as a vehicle for money laundering. Stolen art can also be used as a bargaining chip between crime syndicates.

According to insurance industry estimates the value of stolen art and antiquities worldwide is about $7 billion — a number surpassed only by drugs and armaments. According to Interpol, a number of prominent stolen works are in Canada.

Art Loss Register operates the world's largest private international database, with a list of more than 100,000 "uniquely identifiable stolen and missing items." Since its debut in 1991, it has reportedly recovered up to $355 million worth of missing art. In 1995, Interpol created a database of missing art that currently includes more than 26,000 items. The organization's general secretariat also produces a CD-ROM — updated every two months in English, Spanish, French, and Arabic — of all the missing items and provides it to museums, antique dealers, and collectors. The FBI has a page devoted to art theft on its website, www.fbi.gov/hq/cid/arttheft/arttheft.htm, including a list of its ten most wanted stolen artworks. The International Foundation for Art Research (IFAR), a non-profit organization, offers "impartial and authoritative information on authenticity, ownership, theft, and other artistic, legal, and ethical issues concerning art objects." Its website is www.ifar.org.

Stolen artwork is a growth industry, and anyone buying fine art today has to be sure of its provenance and the reputation of the seller. A book called *Artful Ownership*, by Aaron M. Milrad,[115] outlines in detail the laws in Canada, Mexico, and the United States concerning your rights and responsibilities with regards to having stolen artworks in your possession. In many cases, you are not the real owner of the artwork, even if you purchased it with the best of intentions and had it in your possession for years.

The other main area of theft in the current art market deals with antiquities that are looted from archeological sites around the world and smuggled out of the country and into the hands of middlemen or directly to eager collectors. Some of these stolen objects end up in museums or are offered up at an auction. Numerous national governments are asking for the return of items taken without their permission that they consider to have been stolen. Greece wants the return of the Elgin Marbles, taken in 1806 by Thomas Bruce, the 7th Earl of Elgin, from the Parthenon near Athens and transported to the British Museum in London; they are now displayed in the museum's Duveen Gallery, which was designed for that

purpose. Italy has set up its own "Command for the Preservation of Cultural Heritage," with offices in eleven cities across the country. Since 1969, this unit has been responsible for the return of 185,000 stolen art objects and 455,000 archeological objects. It has also confiscated more than 60,000 fakes, many of them copies by contemporary Italian artists. One of the largest thefts of cultural property of all time happened in March–April 2003, when, as a result of the ongoing war, Iraqi cultural institutions and archaeological sites were raided and suffered major losses of priceless historical artifacts. Looting from archeological sites around the country still continues on a massive scale. A number of artifacts stolen from the Iraqi National Museum have been returned, but between seven and ten thousand are still missing!

A great deal of controversy in the art world today involves artwork stolen or taken under duress by the Nazis in Europe between 1932 and 1945. According to estimates the Nazis stole some 600,000 pieces of art during the twelve years Hitler was in power. Museums and individuals are being asked to disclose the provenance of all artworks in their possession that changed hands during that period. The National Gallery of Canada says it has one hundred works of art with undocumented provenance acquired during the Nazi era. The museum is posting the artwork to its website in an attempt to track down details. The National Gallery recently returned an important early-twentieth-century painting stolen by the Nazis during the Second World War to its original owners in France. *Le Salon de Madame Aron*, by Édouard Vuillard, was purchased from the Galerie Jacques Dubourg in Paris in 1956. Years of investigative research has proven that the 1904 painting of a Paris salon came from a collection stolen in the 1940s from Alfred Lindon, a businessman from a prominent French Jewish family living in Paris. And just recently, in late 2006, the return of some stolen Gustav Klimts was mostly responsible for the highest auction sale in history at Christie's in New York.

As a collector it is important to know about these issues; you would not want to purchase an artwork only to find out later that it was illegally imported or stolen. You have to make sure that your artwork is clean by buying from reputable dealers and auction houses that will guarantee that the artwork has not been stolen and that they have researched its provenance. If you are offered something that sounds too

good to be true, it probably *is* too good to be true. The first document you need whenever you buy art is a proof of purchase — a receipt. The second document you need is a guarantee or certificate of authenticity signed and dated by the seller, the artist, or an independent authority qualified to make the determination of authenticity. The third document you need, especially when you are buying art that is not brand new, is a condition report — a statement verifying the art's condition at the time of purchase. Finally, you need an unconditional money-back guarantee if everything is not as described.

One illegal art scheme you have to watch out for is art donation or art-flip deals promising you incredible tax savings. This is how it works according to the CRA. A promoter gives you the opportunity to purchase one or more works of art or another item of speculative value at a relatively low price. The proposal is that the promoter will work with you to make arrangements to donate the art to a specific registered Canadian charity or other institution. The art is then donated on your behalf and you receive a tax receipt from the institution that is based on an appraisal arranged by the promoter. The appraised value of the art is substantially higher than what you paid for it. You claim the receipt on your next tax return and it generates a tax savings that is higher than the amount you paid for the art in the first place. If the CRA determines upon future scrutiny that your gift was claimed at an inflated value, the claim will be disallowed or adjusted. There may also be penalties and interest assessed retroactively.

The CRA has been aggressive in going after these schemes and so far has been very successful at prosecuting them. Its advice is to be wary of schemes that sell batches of art or shares in art that are valued at several times their cost and that promise substantial tax savings through charitable tax receipts. Be especially wary if you do not get to see the art, or if the charity has been pre-selected for you. Pay close attention to statements or professional opinions in any documents that explain the income tax consequences of the investment. Ask promoters and others to provide written assurances of the transaction's legality. Ask the promoter for a copy of any advance income tax rulings from the CRA about these particular investments and donations. Review the rulings carefully. And finally, before signing any documents, consult a professional tax advisor to obtain competent and independent advice.

Another concern that may arise with art purchases involves payment of all the proper sales taxes, including PST, GST, and (in Quebec and Eastern Canada) HST. In many cases, the taxes are a convenient discount a dealer or gallery owner can offer on an expensive painting. Or you might inquire how much the painting would be if you pay for it with cash. Just be aware that the taxes must be paid by someone, either you or the seller, unless you are buying from a private individual not employed in the art business. It is important that your receipt for the artwork shows that the taxes have been calculated into the sale and records the seller's business number. This is important not only for legal reasons but also because it may come up again if and when you want to sell the art or you need to verify its actual cost, not including taxes, in years to come.

Some of you may have heard of the sales tax avoidance scheme set up by former Tyco International CEO Dennis Kozlowski. He has acknowledged that in order to avoid paying New York's 8.25 percent sales tax, he conspired with his dealer to prepare false invoices indicating that the works had been shipped out of state to an office in Connecticut, when in fact they were sent to his Manhattan apartment. He and his dealer were charged with conspiracy to evade about $1 million in New York sales tax on art purchases. If you live in Alberta, the only Canadian province without a provincial sales tax, and you buy an artwork anywhere west of Quebec, you do not have to pay the provincial taxes in that province only if the artwork is shipped out of the province to your home or office in Alberta and you can prove that by a shipping bill of lading, which shows the pick-up and delivery addresses along with all the other pertinent information.

Insurance

Morton Shulman said, "There can only be one real security for art investment and that is insurance."[116] Insurance for art and art collections is a very specialized field. The input and advice of a fine art insurance specialist well-versed on market values and adequate coverage policies is invaluable. Some things to consider with a fine arts policy include: Is

the artwork insured for its full replacement cost? Is that amount based on a current appraisal or will its value be assessed at the time of the loss? Are there limits on where the artwork can be exhibited? What are the exclusions to the policy? If you own more than one piece, are the artworks covered individually or is the collection covered as a whole? Are there limits to the amounts of the coverage, and if so, what are those limits? Is the artwork covered when being transported or cared for by a third party? Are pairs and sets covered? What happens if there is a partial loss and a subsequent depreciation of value? What is the policy on salvage arrangements and do you have any rights to salvage? Is breakage or deterioration covered under any circumstances?

There are various types of policies you can purchase from an insurance company. Each one looks at loss and damage in a different way and comes with varying amounts of coverage and various exclusions, conditions, and, of course, premiums. You have to determine which policy fits your individual needs and protects your collection in the best and most cost efficient manner. Some of the available policies are:

1. The Standard Homeowners Policy: This type of policy can have very low limits on the amount it will cover for fine arts and other valuables unless you list them as separate or scheduled items.
2. The All-Risk Fine Art Policy: Every work is valued and scheduled under this policy, and in the event of a total loss that predetermined value is paid out. With this type of policy you have to keep your art valuations up to date by means of current, professional appraisals.
3. An Open or Unvalued Fine Art Policy: With this policy the value is determined at the time of loss by means of a professional appraisal.
4. An Individual Risk Policy: This type of policy insures your artwork against a specific loss such as a fire. This type of coverage is used only by institutions.
5. The Blanket or Broad Coverage Policy: This type of policy covers the collection as a whole rather than covering each artwork on its own.

Fine art insurance premiums are based on unique variables such as mediums, breakage capability, geographical locations, materials and type of home construction, local crime statistics, proximity to the fire department or hydrants, and the efficiency and complexity of your alarm system. Other factors such as market values, reimbursement rates, claims history, and the common problem of underinsurance or coinsurance make determining which policy best suits your particular needs a specialist's domain.[117]

As the value of the art market increases and your collection along with it, it would be advisable to review your policy on a regular basis (most insurance companies suggest every two to five years) to keep up with current replacement values. This may involve having appraisals done by qualified and licensed appraisal specialists. You can refer to the websites cited in Appendix C to find sources for accredited fine art appraisers. Insurance of a valuable fine art collection can be a complicated and expensive proposition, so it is necessary to discuss your options with a licensed insurance agent or broker as soon as possible after acquisition — *before* anything happens.

To protect your art you have to keep a detailed description of each piece that includes the type of object, title, artist, date or period, materials used, measurements, inscriptions and markings, and any other distinguishing features. You should have two good, clear photographs or digital picture files of the art — one in colour and one in black and white (if the art ever gets stolen, black and white photographs reproduce better in publications). Then keep the inventory and photos in a safety deposit box or some other separate location. If your home is damaged by fire or flood, you don't want to lose your collection and your inventory at the same time.

Copyright

Even though you own a painting or work of art you do not own the copyright. All paintings and drawings, whether on canvas or on the back of a napkin, are protected by copyright. The copyright is in force for "the life of the author, the remainder of the calendar year in which the

author dies, and a period of fifty years following the end of the calendar year." The owner of the copyright has the sole and exclusive right to "produce or reproduce the work or any substantial part thereof in any material form whatever." The copyright owner must consent to each and every copyrighted use of a work.

There are a number of finer points to the Copyright Act having to do with exhibiting a painting, reproducing it, or modifying it in any way, but the intent of the legislation is that you must get the consent of the artist and/or copyright owner in order to do most anything commercially with an artwork. On the other end of the scale, the copyright holder has no rights in the resale of a work, unless such rights have been previously agreed on within a contract. A copyright holder has three years in which to sue the violator from the start of the copyright infringement.

The responsibilities and legalities involved in purchasing fine art and protecting it (and yourself) once you own it may seem daunting. The art market is rife with pitfalls — scams, frauds, and thefts — but if you do your homework and take the proper precautions you will be fine. I trust that knowing about these issues will not discourage you from buying and investing in art but rather will help you to enjoy your art more, with confidence and free from worry.

EPILOGUE

The Value of Art

Clients and friends who are relatively new to the art world have often told me that they would like to have more quality art in their lives, but they aren't exactly sure where to start or they're afraid of making ill-advised investment choices. I trust that after reading this book they — and you — are now equipped with all the basic knowledge necessary to be able to invest with confidence in the Canadian art market. In truth, you have been given much more information and details than you really need to buy what you love and are able to afford. Now, when you see an artwork that speaks to you, you know how to recognize it for what it really is, and you know the ins and outs of buying it, whether from a gallery, at an auction, or from almost any other source. Once you've taken your new piece of art home and hung it on the wall, you can be assured that it will keep on giving you a return on your investment every single time you look at it. You cannot lose if you love it! All that is needed now is for you, armed with this information, to go and seek out artists and venues that personally appeal to you.

It is my hope that this book will encourage more Canadians to buy original art with confidence and to begin to think of having art in their lives as a necessity rather than an afterthought. Many great philosophers and art scholars, from Plato to Freud, have commented on the value that art brings to individuals and to society, but in my opinion, art plays an essential role in our individual sense of well-being and helps us to understand and communicate with one another on a much deeper level. In the words of the first Group of Seven catalogue, dated May 7, 1920, "The greatness of a country depends on three things: its words, its deeds

and its Art." In my personal experience, being surrounded by the colour, mystery, and beauty of art adds a depth and richness to my day-by-day existence that I find extremely satisfying. My desire is for you to experience that joy and happiness in your life to a greater and greater degree, by investing in more original Canadian art.

Canadian artists need us to support their work so they can continue to concentrate on making great art for us to enjoy. Vincent Van Gogh compared the role of the buyer of art to artists themselves: "I wish I could manage to make you really understand that when you give money to artists, you are yourself doing an artist's work, and that I only want my pictures to be of such a quality that you will not be too dissatisfied with your work." And that was from an artist who sold only one painting while he was alive! How many aspiring Van Goghs are out there who need our support during their lifetimes?

The more deeply you indulge yourself in the world of art, the more you will see that there is an almost inexhaustible supply of superb art, both contemporary and historical; information, both formal and informal; and personalities, both remarkable and passionate. The study of art makes for a fascinating study of the way we operate as individuals, as a culture, and as citizens of this planet. As G. Blair Laing said, "However the climate of art responds to changing times and economics, the creation of works of art will endure as one of man's most hallowed achievements, and an appreciation of them will live on. Art, in whatever form it has taken in the past, and whatever guise it may assume in the future, will last as long as people exist on this planet, and will probably remain mankind's most glorious legacy."[118]

I trust you are better informed and feel more confident about investing in the Canadian art market than before you started. If you have any questions or comments, I would be happy to answer them at abryce@passagesart.com, or you can visit my website at www.passagesart.com. I would like to leave you with this final thought from Arthur Lismer, a member of the Group of Seven and an early teacher of Doris McCarthy: "Inside each one of us is an artist … a child who has never lost the gift of looking at life with curiosity and wonder. Art is not the exclusive possession of those who can draw, write poems, make music or design buildings. It belongs to all those who can see their way through all things with imagination."[119]

Canadian Fine Art Auction Houses

Toronto

Waddington's Auctions
111 Bathurst Street
Toronto, ON
M5V 2R1
www.waddingtons.ca
877-504-5700 or 416-504-9100

Joyner Waddington's
111 Bathurst Street
Toronto, ON
M5V 2R1
www.joyner.ca
877-504-5700 or 416-504-5100

Sotheby's
9 Hazelton Avenue
Toronto, ON
M5R 2E1
www.sothebys.com
416-926-1774

Ritchies
380 King Street East
Toronto, ON
M5A 1K9
www.ritchies.com
416-364-1864

OTTAWA

Walker's Fine Art & Estate Auctioneers
81 Auriga Drive, Suite 18
Ottawa, ON
K2E 7Y5
www.walkersauctions.com
613-224-5814 or 866-224-5814

CALGARY

Levis Fine Art Auctions & Appraisals
1739-10 Avenue Street SW
Calgary, AB
T3C 0K1
www.levisauctions.com
403-541-9099

VANCOUVER

Maynards
415 West 2nd Avenue, 2nd Floor
Vancouver, BC
V5Y 1E3
www.maynards.com
604-876-6787

ALL CANADA

Heffel Fine Art Auction House
www.heffel.com
800-528-9608 or 604-732-6505

A Selection of Listed Artists

Canadian Artists of Note

Painters

Sybil Andrews (1898–1992), Ronald Bloore (1925–), Frederick S. Haines (1879–1960), E.J. Hughes (1913–), William Kurelek (1927–1977), Albert Franck (1899–1973), John Little (1928–), John Kasyn (1926–), J.W. Morrice (1865–1924), Laura Munz (1860–1930), W.J. Phillips (1884–1963), Bill Reid (1920–1998), Tony Scherman (1950–), Gordon Smith (1919–), Ron Bolt (1938–), Doris McCarthy (1910–), Alexander Colville (1920–), Mary Pratt (1935–), Arthur McKay (1926–2000), Michael Snow (1929–), Harold Klunder (1943–), Grant MacDonald (1909–1987), Jean McEwan (1923–1999), Norval Morrisseau (1931–), Allen Sapp (1929–), Maud Lewis (1903–1970), Jane Ash Poitras (1951–), Christopher Pratt (1935–), Takao Tanabe (1926–),Ted Goodwin (1933–), Joyce Weiland (1931–1998), David Thauberger (1948–), Frederick Taylor (1906–1987), Greg Curnoe (1936–1992), David Bierk (1944–2002), Ken Danby (1940–), Robert Bateman (1930–), John Forrestal (1936–), Arthur Schilling (1941–1986), Daphne Odjig (1919–), Jack Shadbolt (1909–1998), Suzanne Bergeron (1930–), Sam Borenstein (1908–1969), Fritz Brandtner (1896–1969), Stanley Cosgrove (1911–2002), Suzanne Duquet (1917–), Pierre Gauvreau (1922–), Henri Masson (1907–1996), Guido Molinari (1933–2004), Claude Tousignant (1932–), Nicholas de Grandmaison (1892–1978), Robert Pilot (1898–1967)

Sculptors

Sorel Etrog (1933–), Joe Fafard (1942–), Henri Hébert (1884–1950), Maryon Kantaroff (1933–), Alfred Laliberté (1878–1953), William

McElcheran (1927–1999), Leo Mol (1915–), Marc-Aurèle de Foy Suzor-Côté (1869–1937)

Canadian Art Groups

THE GROUP OF SEVEN

Franklin Carmichael (1890–1945), A.J. Casson (1898–1992), LeMoine FitzGerald (1890–1956), Lawren Harris (1885–1970), Edwin Holgate (1892–1977), A.Y. Jackson (1882–1974), Frank (Franz) Johnston (1888–1949), Arthur Lismer (1885–1969), J.E.H. MacDonald (1873–1932), Tom Thomson (1877–1917), F.H. Varley (1881–1969)

HISTORICAL CANADIAN PAINTERS

Frederic Marlett Bell-Smith (1846–1923), Lucius O'Brien (1832–1899), Frederick Arthur Verner (1836–1928), William Brymner (1885–1925), Paul Peel (1860–1892), Robert Harris (1849–1919), John Hammond (1843–1939), George Reid (1860–1947), Marc-Aurèle de Foy Suzor-Côté (1869–1937), Homer Watson (1855–1936), Ozias Leduc (1864–1955), Frederick Banting (1891–1941), Paul Kane (1810–1871), Cornelius Krieghoff (1815–1972)

THE CANADIAN GROUP OF PAINTERS

B.C. Binning (1909–1976), Bertram Brooker (1888–1955), Emily Carr (1871–1945), Paraskeva Clark (1898–1986), Charles Comfort (1900–1994), Marc-Aurèle Fortin (1888–1970), Thoreau MacDonald (1901–1989), Yvonne McKague Housser (1897–1996), Jack Humphrey (1901–1967), Pegi Nicol MacLeod (1904–1946), David Milne (1882–1953), Isabel McLaughlin (1903–2002), Jock Macdonald (1897–1960), Will Ogilvie (1901–1989), George Pepper (1903–1962), Kathleen Daly Pepper (1898–1994), Goodridge Roberts (1904–1974), Albert H. Robinson (1881–1956), Carl Schaefer (1903–1995), Jack Shadbolt (1909–1998), William Weston (1879–1967), York Wilson

(1907–1984), W.J. Wood (1877–1954)

Contemporary Arts Society (CAS)

Marian Dale Scott (1906–1993), John Lyman (1886–1967), Eric Goldberg (1890–1969), Stanley Cosgrove (1911–2002), Paul-Émile Borduas (1905–1960), Alfred Pellan (1906–1988)

Painters Eleven

Jack Bush (1909–1977), Oscar Cahen (1916–1956), Hortense Gordon (1887–1961), Tom Hodgson (1924–2005), Alexandra Luke (1901–1967), Jock MacDonald (1897–1960), Ray Mead (1921–1998), Kazuo Nakamura (1926–2002), William Ronald (1926–1998), Harold Town (1924–1990), Walter Yarwood (1917–1996)

The Beaver Hall Group

Nora Collyer (1898–1979), Emily Coonan (1885–1971), Adrien Hébert (1890–1967), Prudence Heward (1896–1947), Randolph Hewton (1888–1960), Mabel Lockerby (1887–1976), Pegi Nicol MacLeod (1904–1946), Mabel May (1884–1971), Kathleen Morris (1893–1986), Lilias Torrance Newton (1896–1980), Sarah Robertson (1891–1948), Anne Savage (1896–1971), Ethel Seath (1879–1963)

Automatistes

Paul-Émile Borduas (1905–1960), Marcel Barbeau (1925–), Pierre Gauvreau (1922–), Fernand Leduc (1916–), Jean-Paul Mousseau (1927–), Marcelle Ferron (1924–), Jean-Paul Riopelle (1923–2002)

Post-Automatistes

Jean McEwen (1923–1999), Rita Letendre (1929–), Lise Gervais (1933–1998), Guido Molinari (1933–2004), Claude Tousignant

(1932–), Leon Bellefleur (1910–), Jean Philippe Dallaire (1916–1965), Jean-Paul Lemieux (1904–1990)

International Art Movements

Old Masters

Leonardo da Vinci (1454–1519), Albrecht Dürer (1471–1528), Michelangelo (1475–1564), Titian (1476–1576), Raphael (1483–1520), Tintoretto (1518–1594), Pieter Bruegel (1525–1569), El Greco (1541–1614), Frans Hals (1580–1666), Caravaggio (1571–1610), Peter Paul Rubens (1577–1640), Poussin (1594–1665), Velázquez (1599–1660), Rembrandt (1606–1669), Vermeer (1632–1675)

Impressionists

Pierre-Auguste Renoir (1841–1919), Claude Monet (1840–1926), Edgar Degas (1834–1917), Mary Cassatt (1845–1926), Auguste Rodin (1840–1917)

Post-Impressionists

Paul Cézanne (1839–1906), Paul Gauguin (1848–1903), Vincent Van Gogh (1853–1890), Georges Seurat (1859–1891), Henri de Toulouse-Lautrec (1864–1901)

Expressionists

Edvard Munch (1863–1944), Henri Matisse (1869–1954), Wassily Kandinsky (1866–1944), Amedeo Modigliani (1884–1920)

Cubists

Pablo Picasso (1881–1963), Georges Braque (1882–1963), Juan Gris (1887–1927), Fernand Léger (1881–1955), Constantin Brancusi (1876–1957)

Dadaists

Max Ernst (1891–1976), Man Ray (1890–1977), Marcel Duchamp (1887–1968), Joan Miró (1893–1983)

Surrealists

Salvador Dali (1904–1989), Marc Chagall (1187–1985), René Magritte (1898–1967), Alberto Giacometti (1901–1966), Meret Oppenheim (1913–1989)

Abstract Expressionists

Jackson Pollock (1912–1956), Willem de Kooning (1904–1997), Mark Rothko (1903–1970), Robert Motherwell (1915–1991), Barnett Newman (1905–1971)

Pop Artists, Minimalists, and Conceptualists

Andy Warhol (1928–1987), Roy Lichtenstein (1923–1997), Jasper Johns (1930), Robert Rauschenberg (1925–), Frank Stella (1936–), Carl Andre (1935–), Eva Hesse (1936–1970)

Print and Online Resources

Books:

McMann, Evelyn de R. (ed.) *Biographical Index of Artists in Canada.* Toronto: University of Toronto Press, 2002. This quick reference guide contains biographies of more than 9,000 professional and amateur artists active in Canada from the seventeenth century to the present.

Newlands, Anne. *Canadian Art: From Its Beginnings to 2000.* Toronto: Firefly Books, 2000. This is a coffee table book with each page devoted to one artist with a concise biography and an example of their work.

Reid, Dennis. *A Concise History of Canadian Painting*, 2nd edition. Toronto: Oxford University Press, 1988. This is a comprehensive and yet very readable summary of Canadian art history. Highly recommended as a beginner's resource guide.

Silcox, David P. *The Group of Seven and Tom Thomson.* Toronto: Firefly Books, 2003. A lush and colorful coffee table book.

Vinson, James (ed.). *International Dictionary of Art and Artists.* Chicago: St. James Press, 1990. This is an encyclopedic overview of all major European and American artists and artworks.

Walters, Evelyn. *The Women of Beaver Hall: Canadian Modernist Painters.* Toronto: Dundurn Press, 2005. This beautiful book covers each of the painters of the Beaver Hall Group with fine reproductions of their works along with complete biographical details.

Westbridge, Anthony R. and Diana L. Bodnar. *The Collector's Dictionary of Canadian Artists at Auction.* Vancouver, BC: Westbridge Publications Ltd., 1999–2003. This four-volume work includes comprehensive biographical listings for more than 3,000 Canadian artists and historical artists active in Canada during their career, from the 1700s to the present.

McCarthy, Doris, with Charis Wahl. *My Life.* Toronto: Second Story Press, 2006. The story of the artist's early and mid-career as a painter.

These are just a few of the literally millions of books, encyclopedias, dictionaries, biographies, and reference books covering every conceivable subject on art. (See also the bibliography in this book.)

Magazines (print and online):

American Art Review covers American artists and American art history.

Art & Auction specializes in the auction scene and the art market, in the U.S. and worldwide.

Artnet Magazine offers daily art-related news online at www.artnet.com.

ARTnews reports on the international art world.

The Art Newspaper provides in-depth, up-to-the-minute reporting in the art world.

Arts News Canada provides regular art updates and news online at www.artsnews.ca.

Border Crossings examines contemporary Canadian and international art and culture.

Canadian Art covers the Canadian art scene from coast to coast.

The Saturday *Globe and Mail* contains the bulk of the advertisements for the new art shows, mainly in Toronto, but also across Canada.

Gordon's Print Price Annual is the best reference for print auction records.

Magazin'Art highlights Canadian, and especially Quebecois, artists.

Modern Painters focuses on the contemporary international art world.

National Post has good arts coverage.

Websites:

• www.artprice.com provides detailed auction records, listings of upcoming auctions, research on individual artworks, and artists' biographies.

• www.artnet.com has everything you need to research past auction records plus an index of more than 16,000 galleries, a list of 185,000 artists, and price records for more than 2 million lots sold at more than 500 auction houses.

- Ask Art, **www.askart.com**, provides auction records and information on more than 35,000 American artists.
- Gordon's Art Sales Index, www.gordonsart.com, is a database that focuses on prints and photography.
- UCLA's Art Library website, **www.library.ucla.edu**, offers excellent help finding catalogues raisonnés.
- International Foundation for Art Research (IFAR), **www.ifar.org**, offers an impartial and authoritative art authentication service. For $2,000 you get the peace of mind of knowing that your painting is authentic.
- **www.westbridge-fineart.com** provides you with a free access to Canadian auction results. You can also look up past reports and order his publications.
- **www.art-collecting.com** provides online resources for art collecting, including services related to buying, selling, and marketing artworks and works with artists, galleries, and collectors.
- **www.ArtBusiness.com**, provides art appraisals, art price data, news, articles, and market information to art collectors, artists, and fine arts professionals. Its services include appraising all works of fine art and consulting on buying, selling, donating, and collecting fine art. Its database contains more than 4,500,000 price records and biographical information for more than 325,000 artists.
- **www.yourartlinks.com** is the largest directory for American artists and art related sites.
- **www.art-sales-index.com** has the prices and information of fine art sold at auction around the world over the past thirty-four years. The database holds more than 2.9 million auction entries by 225,000 artists.
- **www.artfact.com** has a database that contains more than 20 million auction lots and over $100 billion worth of price results.
- The Centre for Contemporary Canadian Art, **www.ccca.ca**, has an extensive database of Canadian art and artists and links to many other Canadian art sites.
- **www.DorisMcCarthy.com** contains current news on Doris and her life along with examples of her work and an extensive biography. It currently features a project where owners of her art can register it on the site to begin a registry of all her works for a possible future CR.

Notes

1 Lynne Wynick, quoted in an advertisement for the Toronto International Art Fair, *Canadian Art*, Fall 2002, 65.

2 Dennis Reid, *A Concise History of Canadian Painting*, Second Edition (Don Mills, ON: Oxford University Press, 1988), 181.

3 Steve Martin, "A Word on Art Collecting," *Modern Painters*, Spring 2003, 63.

4 Ross King, *The Judgment of Paris: The Revolutionary Decade That Gave the World Impressionism* (Toronto: Anchor Canada, 2006), 356.

5 Ann Landi, "The Turning Tides of Taste," *ARTnews*, November 2002, 236.

6 Glen Warner, *Building a Print Collection: A Guide to Buying Original Prints and Photographs* (Toronto: Key Porter Books, 1984), 41.

7 Kelly Devine Thomas, "The 10 Most Expensive Living Artists," *ARTnews*, May 2004, 124.

8 Landi, "The Turning Tides of Taste," 236.

9 Darian Leader, *Stealing the Mona Lisa: What Art Stops Us from Seeing* (New York: Counterpoint, 2002), 51.

10 Jori Finkel, "Bound for Glory," *Art & Auction*, December 2006, 90, quoting from E.H. Gombrich, *The Story of Art* (London, UK: Phaidon Press, 1995).

11 Heller, *Why a Painting Is Like a Pizza*, 10–11.

12 Wikipedia contributors, "Oil Paint," *Wikipedia, The Free Encyclopedia*, http://en.wikipedia.org/wiki/Oil_paint.

13 Cassandra James, "Glow of oils," letter in response to "Acrylic Snobs," by Robert Genn, June 2, 2006, *The Painter's Keys*,http://www.painterskeys .com/clickbacks/acrylic-snobs.asp.

14 Brad Faegre, listed under "Acrylics Art Quotations," *The Painter's Keys*,http://quote.robertgenn.com/getquotes.php?category=acrylics.

15 Frederick Whitaker (1891–1980), quoted in an advertisement for The Frederic Whitaker and Eileen Whitaker Foundation, *ARTnews*, June 2002, 67.

16 Amanda McLean, listed under "Pastels Art Quotations," *The Painter's Keys*, http://quote.robertgenn.com/getquotes.php?category=pastels.

17 Phil Metzger, *The Artist's Illustrated Encyclopedia: Techniques, Materials, and Terms* (Cincinnati, OH: North Light Books, 2001), 341.

18 Alan Klevit, *Art Collecting 101: Buying Art for Profit and Pleasure* (Booklocker.com, 2005), 19.

19 Klevit, *Art Collecting 101*, 11.

20 Klevit, *Art Collecting 101*, 12.

21 Klevit, *Art Collecting 101*, 11–2.

22 Warner, *Building a Print Collection*, 41.

23 Dennis Reid, *A Concise History of Canadian Painting*, Second Edition (Don Mills, ON: Oxford University Press, 1988), 141.

24 S.N. Behrman, *Duveen: The Story of the Most Spectacular Art Dealer of All Time* (New York: The Little Bookroom, 2003), 139.

25 Brook Mason, "Principals of Design," *Art & Auction*, May 2003, 80.

26 Michelle Falkenstein, "Border Patrol," *ARTnews*, September 2002, 134.

27 Klevit, *Art Collecting 101*, 41.

28 Klevit, *Art Collecting 101*, 42.

29 Davis, *Art Dealer's Field Guide*, 118.

30 Jerzy Nanowski quoted in an advertisement for Toronto International Art Fair, *Canadian Art*, Fall 2002, 66.

31 Canadian Conservation Institute website (http://www.cci-icc.gc.ca/) and promotional information.

32 Michelle Falkenstein, "Border Patrol," *ARTnews*, September 2002, 135.

33 Adrian Darmon, "Forgeries: A Long History," *Museum Security Network*, http://www.museum-security.org/forgeries.htm.

34 Heller, *Why a Painting Is Like a Pizza*, 34–35.

35 Joe. L. Dolice, "Introduction," *A History of Art Forgery*, 2003, http://www.mystudios.com/gallery/forgery/history/index.html.

36 Thomas Hoving, *False Impressions: The Hunt for Big-Time Art Fakes* (Great Britain: St. Edmundsbury Press, 1996), 56–7.

37 Hoving, *False Impressions*, 74

38 Darmon, "Forgeries."

39 Davis, *Art Dealer's Field Guide*, 163–4.

40 Ben Hills, "Art Forgery: A Brush with Fame," *Sydney Morning Herald*, July 18, 1998, http://web.archive.org/web/20000309173145/http://www.smh.com.au/news/9807/18/features/features2.html.

41 Warner, *Building a Print Collection*, 50–1.

42 Warner, *Building a Print Collection*, 58.

43 Behrman, *Duveen*, 64.

44 Davis, *Art Dealer's Field Guide*, 168.

45 Warner, *Building a Print Collection*, 82–3.

46 Hoving, *False Impressions*, 333.

47 Benhamou-Huet, *The Worth of Art*, 16.

48 Matthew Hart, *The Irish Game: A True Story of Crime and Art* (Toronto: Viking Canada, 2004), xiii.

49 Benhamou-Huet, *The Worth of Art*, 121.

50 Leader, *Stealing the Mona Lisa*, 83.

51 Marques Vickers, *Marketing and Buying Fine Art Online: A Guide for Artists and Collectors* (New York: Allworth Press, 2005), 148.

52 Vickers, *Marketing and Buying Fine Art Online*, 148.

53 Benhamou-Huet, *The Worth of Art*, 17.

54 Benhamou-Huet, *The Worth of Art*, 91.

55 Edward Dolnick, *The Rescue Artist: A True Story of Art, Thieves, and the Hunt for a Missing Masterpiece* (New York: HarperCollins, 2006), 128.

56 Heller, *Why a Painting Is Like a Pizza*, 133.

57 Behrman, *Duveen*, 23–4.

58 Behrman, *Duveen*, 99.

59 Behrman, *Duveen*, 31.

60 Richard Gray, president of the Art Dealers Association of America, "Dealers' Hand" *Art & Auction*, November 2002, 114.

61 Alan Bamberger, *The Art of Buying Art* (Phoenix, AZ: LTB Gordonsart, Inc., 2002), 62.

62 G. Blair Laing, *Memoirs of an Art Dealer 2* (Toronto: McClelland and Stewart Ltd., 1982), 190.

63 Benhamou-Huet, *The Worth of Art*, 43.

64 Vickers, *Marketing and Buying Fine Art Online*, 154.

65 Bamberger, *The Art of Buying Art*, 51.

66 Laing, *Memoirs of an Art Dealer 2*, 188.

67 Ferdinand Protzman, "How Much is Too Much?," *ARTnews*, May 2004, 132.

68 Vickers, *Marketing and Buying Fine art Online*, 179.

69 Benhamou-Huet, *The Worth of Art*, 14.

70 Anthony R. Westbridge, *Made in Canada!: An Investor's Guide to the Canadian Art Market*, 15.

71 Westbridge, *Made in Canada!*, 60.

72 Protzman, "How Much Is Too Much?," 132.

73 Judd Tully, "Mirror, Mirror," *Art & Auction*, May 2002, 85.

74 Thomas and Charles Danziger, "House Rules," *Art & Auction*, March 2004, 62.

75 Danziger, "House Rules," 122.

76 Souren Melikian, "Fetching Prizes," *Art & Auction*, May 2003, 28–30.

77 Davis, *Art Dealer's Field Guide*, 232–3.

78 Ferdinand Protzman, "How Much is Too Much ?," *ARTNews*, May 2004, 133.

79 Mary-Anne Martin, Fine Art in New York, quoted in "Dealers' Hand," *Art & Auction*, November 2002, 115.

80 Jane Kallir, co-director of Galerie St. Etienne in New York, quoted in "Dealers' Hand," *Art & Auction*, November 2002, 114–5.

81 Vickers, *Marketing and Buying Fine Art Online*, 186.

82 Bruce Wolmer, former publisher of *Art & Auction* magazine, quoted in "Dealers' Hand," *Art & Auction*, November 2002, 113–4.

83 Kallir, quoted in "Dealers' Hand," 115–6.

84 Scott Rayburn, "Auction Review," *Art & Auction*, May 2002, 105. The quote is anonymous.

85 Benhamou-Huet, *The Worth of Art*, 9.

86 Vickers, *Marketing and Buying Fine Art Online*, 184–5.

87 Vickers, *Marketing and Buying Fine Art Online*, 185.

88 Meryle Secrest, *Duveen: A Life in Art* (New York: Alfred A. Knopf, 2004), 76.

89 Gil Edelson, quoted in "Dealers' Hand," *Art & Auction*, November 2002, 116–7.

90 Vickers, *Marketing and Buying Fine Art Online*, 159.

91 Mary-Anne Martin/Fine Art in New York, quoted in "Dealers' Hand," *Art & Auction*, November 2002, 114.

92 Steven Vincent, "Fairs: How are they changing the Art Business?" *Art & Auction*, December 1995, 88.

93 Ellen Berovitch, "A Winning Price Gets Dewy Galleries," *Art & Auction*, June 2003, 110.

94 Eileen Kinsella, "Wise Buys," *ARTnews*, Summer 2002, 146.

95 Morton Shulman, *Anyone Can Make Big Money Buying Art* (New York: Macmillan Publishing Co., 1977), 21.

96 Pablo Bachelet, "Argentina: Crisis and Opportunity," *Art & Auction*, June 2002, 28.

97 Tom Flynn, "Smart Money," *Art & Auction*, July 2003, 34.

98 Martin, "A Word on Art Collecting," 63.

99 Martin, "A Word on Art Collecting," 64.

100 Behrman, *Duveen*, 11.

101 Miriam Shell, Miriam Shell Fine Art, Toronto, quoted in an advertisement for the Toronto International Art Fair, *Canadian Art*, Fall 2002, 65.

102 Anthony Westbridge, "Profit You Can Hang on the Wall," *Globe and Mail*, February 22, 2006, E2.

103 Ronald Augustine of New York gallery Luhring Augustine, quoted in "Dealers' Hand," *Art & Auction*, November 2002, 115.

104 Laing, *Memoirs of an Art Dealer 2*, 148.

105 Laing, *Memoirs of an Art Dealer*, 76.

106 Vickers, *Marketing and Buying Fine Art Online*, 175.

107 Davis, *Art Dealer's Field Guide*, Preface.

108 Laing, *Memoirs of an Art Dealer*, 166–7.

109 Emily Carr, Journal, September11, 1933.

110 Martin Gaylord, "The Portrait of the Artist as Collector," *National Post*, November 21, 2006.

111 Gaylord, "The Portrait of the Artist as Collector."

112 Stephen Smart, *Law, Art and the Community* (Vancouver: Self Counsel Press, year), 160.

113 Smart, *Law, Art and the Community*, 156.

114 Dolnick, *The Rescue Artist*, 11.

115 Aaron M. Milrad, *Artful Ownership: Art Law, Valuation, and Commerce in the United States, Canada, and Mexico* (RR Donnelley & Sons and American Society of Appraisers, 2000).

116 Shulman, *Anyone Can Make Big Money*, 102.

117 Vickers, *Marketing and Buying Fine Art Online*, 192.

118 Laing, *Memoirs of an Art Dealer*, 255.

119 Majorie Lismer Bridges, *A Border of Beauty: Arthur Lismer's Pen and Pencil* (Toronto: Red Rock Publishing Company, 1977), 110.

Bibliography

Books:

Behrman, S.N. *Duveen: The Story of the Most Spectacular Art Dealer of All Time.* New York: The Little Bookroom, 2003.

Benhamou-Huet, Judith. *The Worth of Art: Pricing the Priceless.* New York: Assouline, 2001.

Davis, Ron. *Art Dealer's Field Guide: How to Profit in Art, Buying and Selling Valuable Paintings.* Capital Letters Press, 2005.

Hart, Matthew. *The Irish Game: A True Story of Crime and Art.* Toronto: Viking Canada, 2004.

Heller, Nancy G. *Why a Painting Is Like a Pizza: A Guide to Understanding and Enjoying Modern Art.* Princeton NJ: Princeton University Press, 2002.

Hoving, Thomas. *False Impressions: The Hunt for Big-Time Art Fakes*: Great Britain: St Edmundsbury Press, 1996.

Laing, G. Blair. *Memoirs of an Art Dealer.* Toronto: McClelland and Stewart Limited, 1979.

———. *Memoirs of an Art Dealer 2.* Toronto: McClelland and Stewart Limited, 1982.

Leader, Darian. *Stealing the Mona Lisa: What Art Stops Us from Seeing.* New York: Counterpoint, 2002.

Metzger, Phil. *The Artist's Illustrated Encyclopedia: Techniques, Materials, and Terms.* Cincinnati, OH: North Light Books, 2001.

Milrad, Aaron M. *Artful Ownership: Art Law, Valuation, and Commerce in the United States, Canada, and Mexico.* RR Donnelly & Sons and American Society of Appraisers, 2000.

Neuberger, Roy R., with Alfred and Roma Connable. *The Passionate Collector.* Hoboken, NJ: John Wiley & Sons Inc., 2003.

Reid, Dennis. *A Concise History of Canadian Painting*, 2nd edition. Don Mills, ON: Oxford University Press, 1988.

Ruhrberg, K., M. Schneckenburger, C. Fricke, and K. Honnef. *Art of the 20th Century: Painting, Sculpture, New Media, Photography.* New York: Taschen, 2000.

Secrest, Meryle. *Duveen: A Life in Art.* New York: Alfred A. Knopf, 2004.

Shulman, Morton. *Anyone Can Make Big Money Buying Art.* New York: Macmillan Publishing Co. Inc., 1977.

Smart, Stephen. *Law, Art and the Community*. Vancouver: Self Counsel Press, year.

Vickers, Marques. *Marketing and Buying Fine Art Online: A Guide for Artists and Collectors*. New York: Allworth Press, 2005.

Warner, Glen. *Building a Print Collection: A Guide to Buying Original Prints and Photographs*. Toronto: Key Porter Books, 1984.

Westbridge, Anthony R. *Canadian Art: The Investment of the 90's*. Vancouver: Westbridge Publications Ltd., 1990.

———. *Made in Canada! An Investor's Guide to the Canadian Art Market*. Vancouver: Westbridge Publications Ltd., 2002.

Articles:

Bachelet, Pablo. "Argentina: Crisis and Opportunity." *Art & Auction*, June 2002, 26–8.

Berkovitch, Ellen. "A Winning Price Gets Dewey Galleries." *Art & Auction*, June 2003, 110.

Brook, Mason S. "Principals of Design." *Art & Auction*, May 2003, 80–91.

Danziger, Thomas and Charles Danziger. "House Rules." *Art & Auction*, March 2004, 62.

Falkenstein, Michelle. "Border Patrol." *ARTnews*, September 2002, 134–5.

Flynn, Tom. "Smart Money." *Art & Auction*, July 2003, 34.

Gaylord, Martin. "The Portrait of the Artist as Collector." *National Post*, November 21, 2006, AL 5.

Keats, Jonathon. "A Darkroom of Her Own." *Art & Auction*, June 2003, 76–8.

Kinsella, Eileen. "Wise Buys." *ARTnews*, Summer 2002, 146–53.

Landi, Ann. "The Turning Tides of Taste." *ARTnews*, November 2002, 236–43.

Marr, Andrew. "No Ordinary Looking." *Modern Painters*, Spring 2003, 66–9.

Melikian, Souren. "Fetching Prizes." *Art & Auction*, May 2003, 28–34.

———. "New Kid on the Block." *Art & Auction*, November 2001, 40–5.

———. "Off the Beaten Path." *Art & Auction*, October 2002, 48–54.

———. "Passion Plays." *Art & Auction*, March 2003, 30–6.

Meyer, John. "Art Market Strengthening." *Magazin'Art*, Automne/Fall 2002, 116.

Panel Discussion, "Critics and the Marketplace," *Art & Auction*, March 1990, 171–5.

Panel Discussion, "Dealers' Hand." *Art & Auction*, November 2002, 109–16.

Pollock, Lindsay. "At the Fair." *Art & Auction*, February 2003, 48–50.

Protzman, Ferdinand. "How Much Is Too Much?" *ARTnews*, May 2004, 130–3.

Reyburen, Scott. "Auction Review." *Art & Auction*, May 2002, 105.

Rhodes, Richard. "Canadian Art." *Canadian Art*, Winter 2001, 8–10

Spielger, Marc. "A Man in Full." *Art & Auction*, May 2002, 86–97.

Thomas, Kelly Devine. "The 10 Most Expensive Living Artists." *ARTnews*, May 2004, 118–29.

Vincent, Steven. "Fairs: How Are They Changing the Art Business." *Art & Auction*, December 1995, 88–91.